Studies in Mixed Media

Figures and Designs for the Month of May 2013

By Benjamin Long.

Illustrations by Benjamin Long for the Month of May. New Illustrations and commission work that was requested of me. Many pieces feature the cartoon/ cross hatch style that I have been working on as well as a few underpaints.

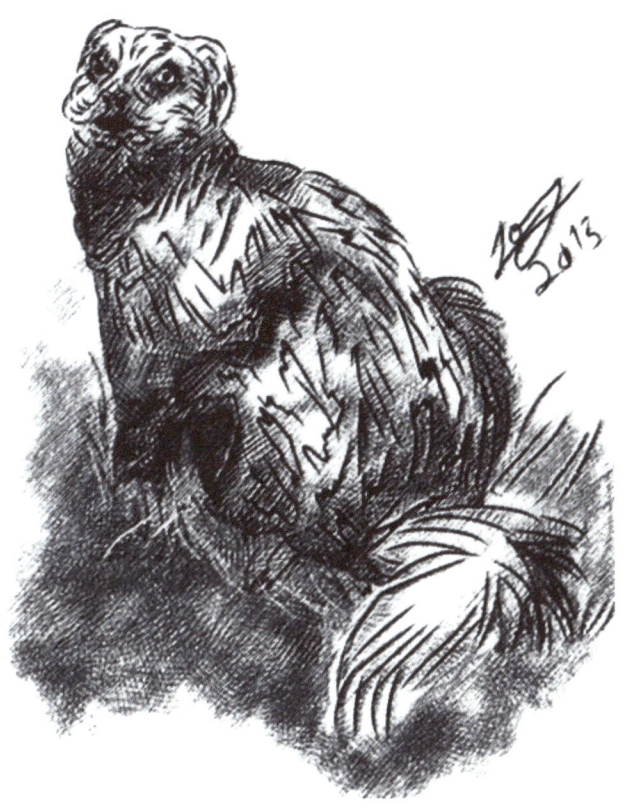
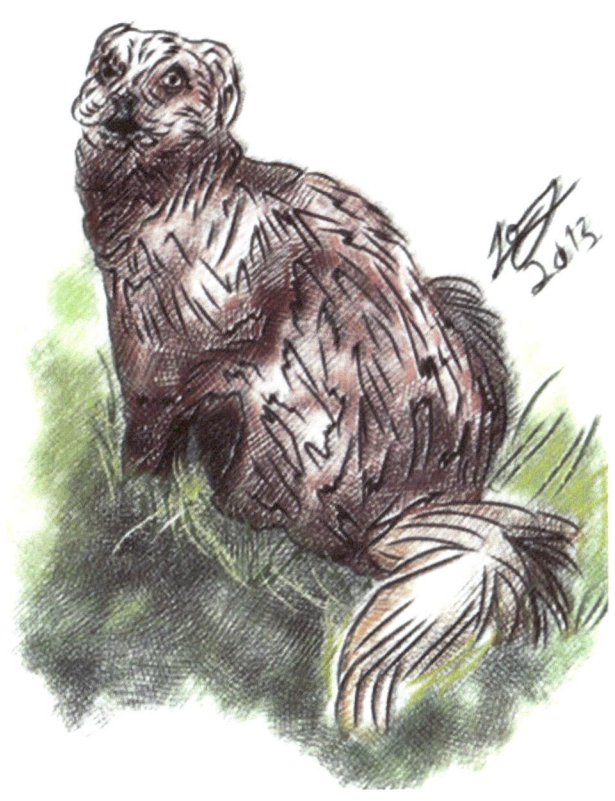

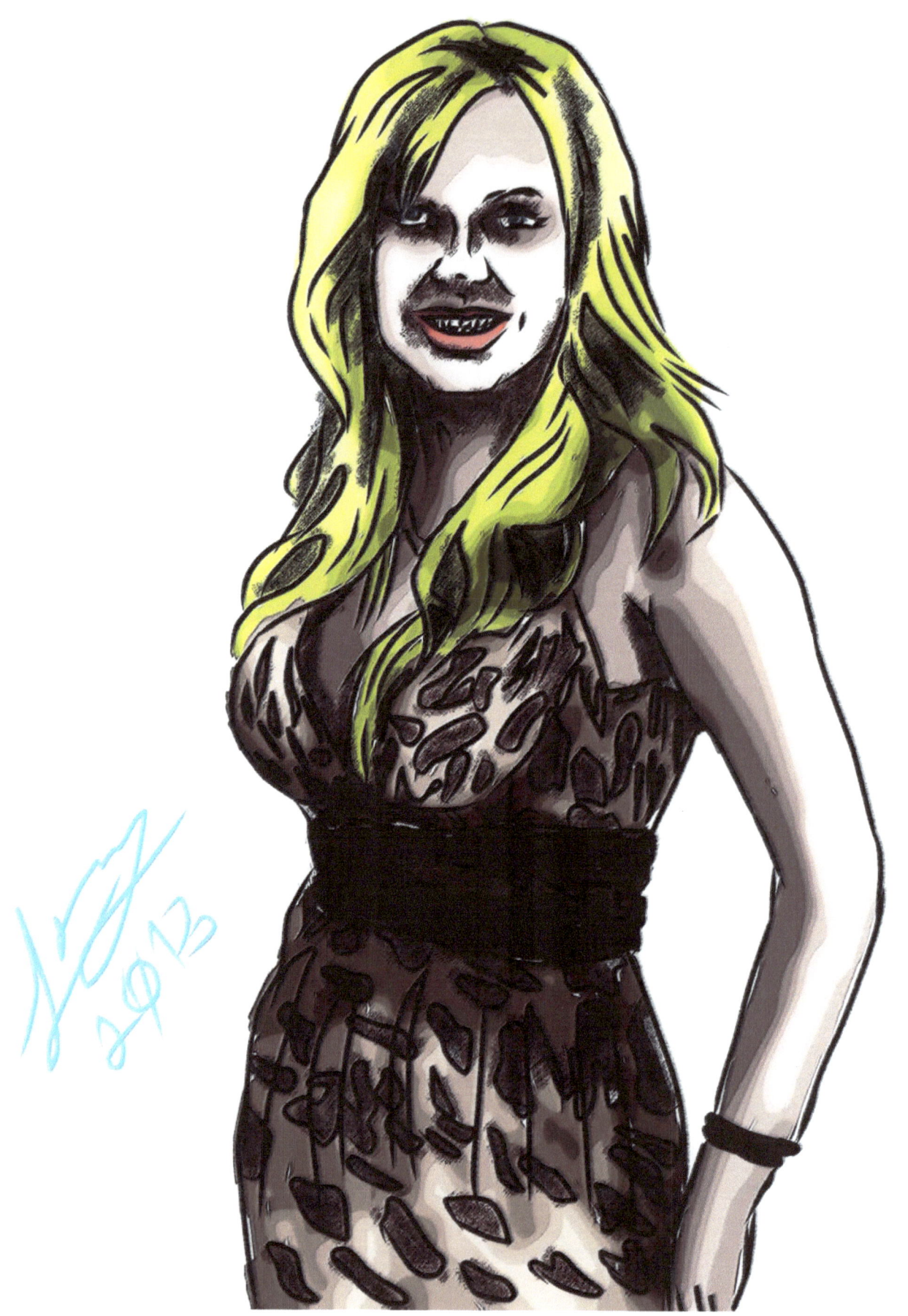

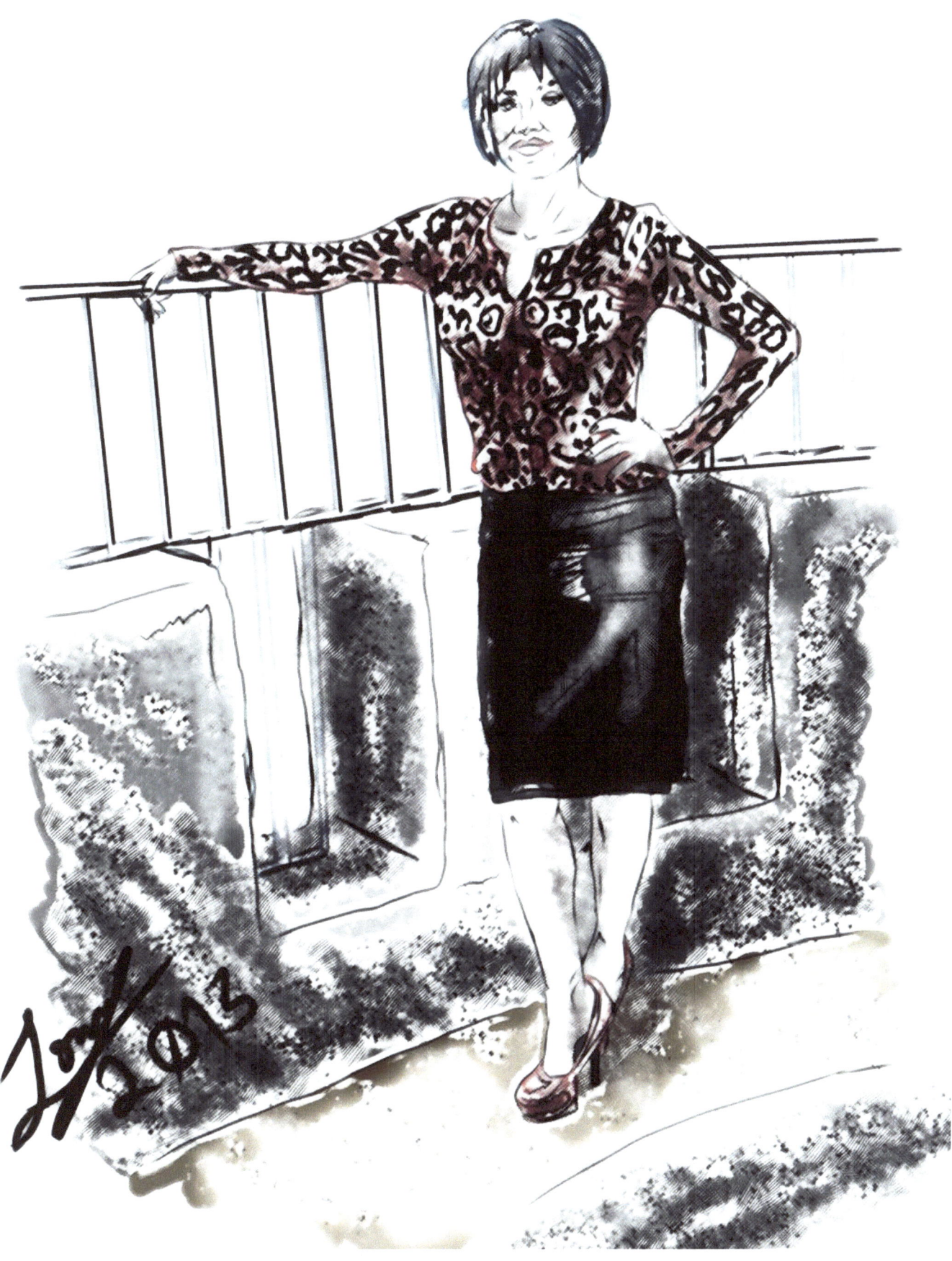

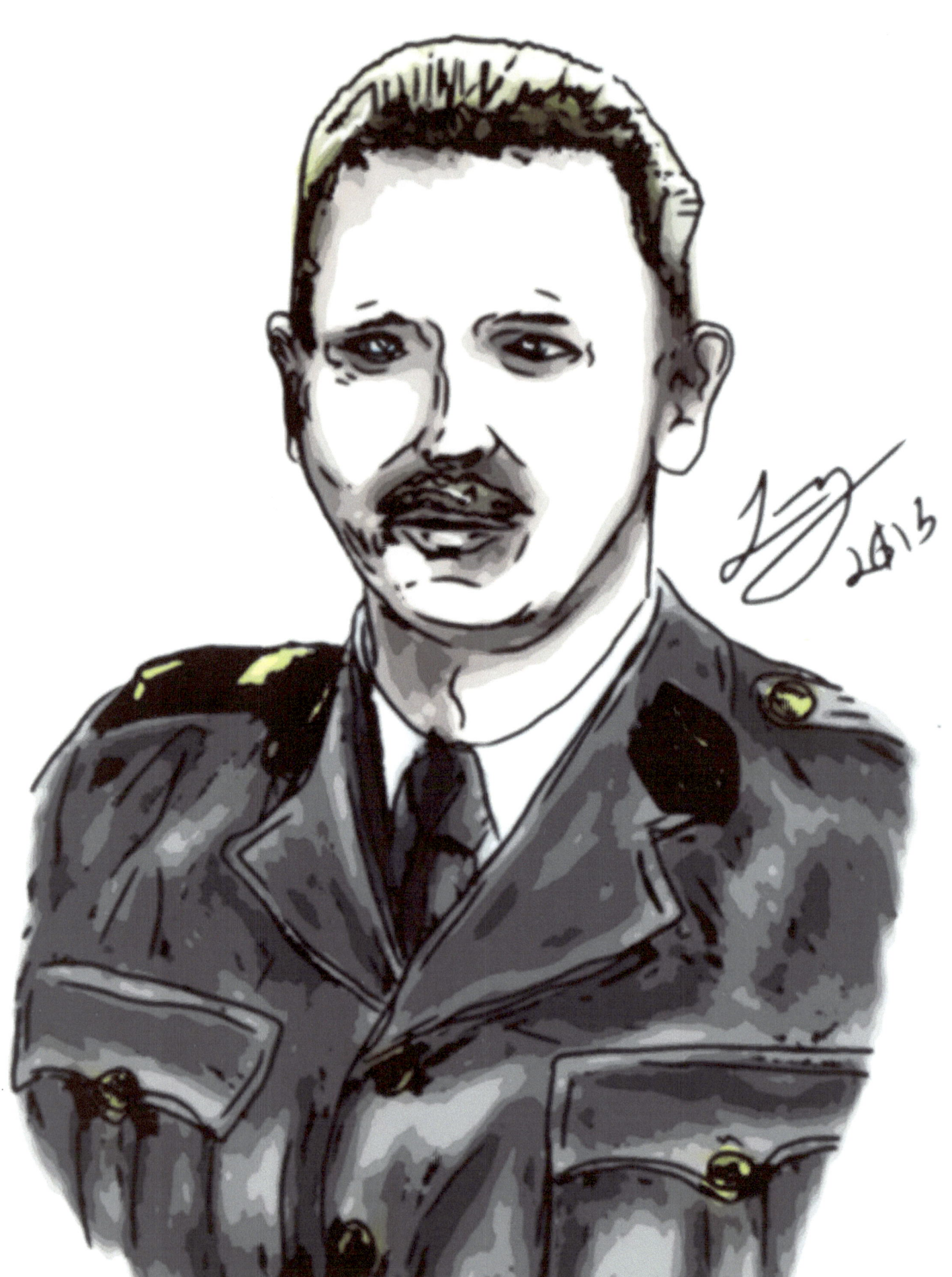

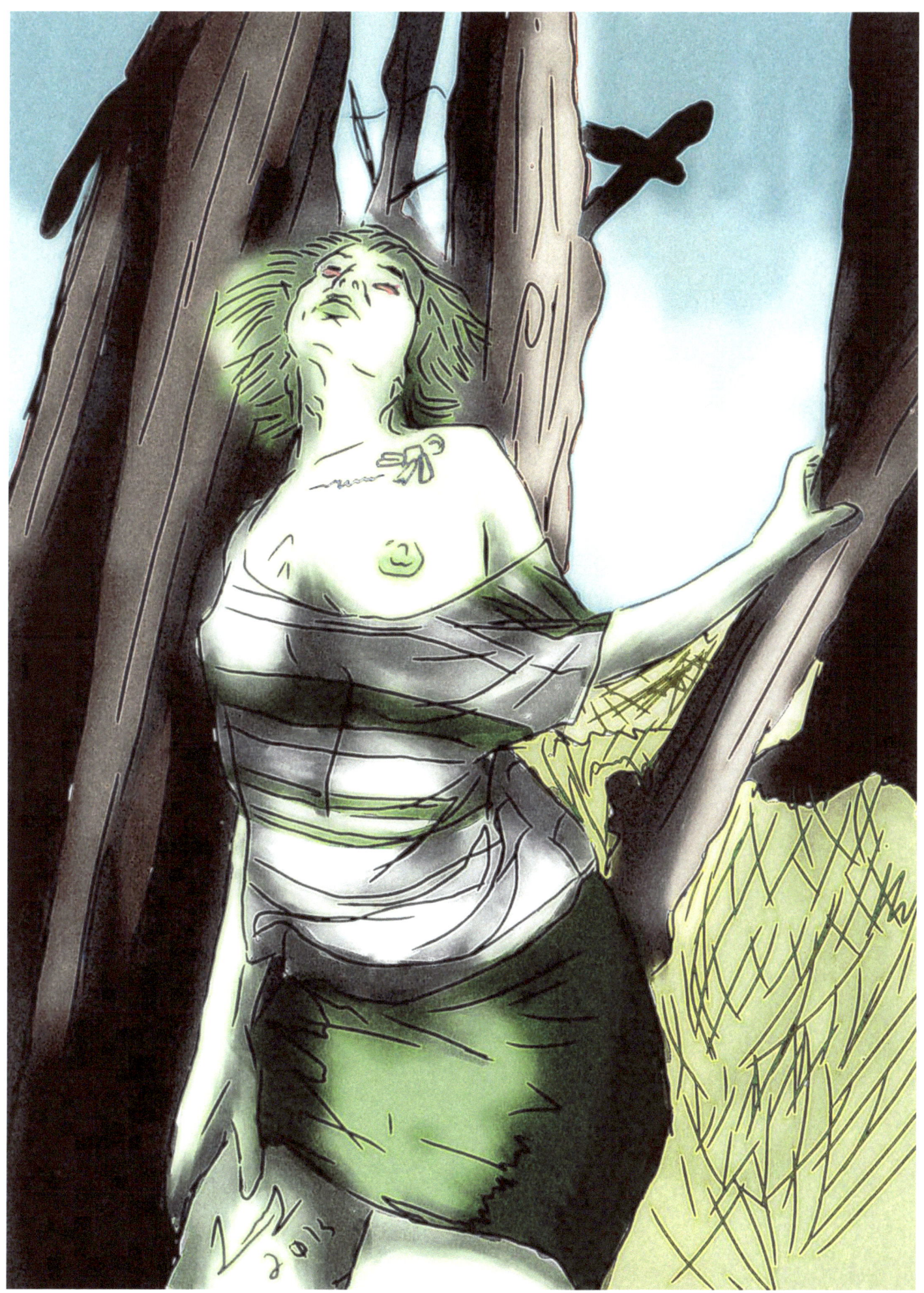

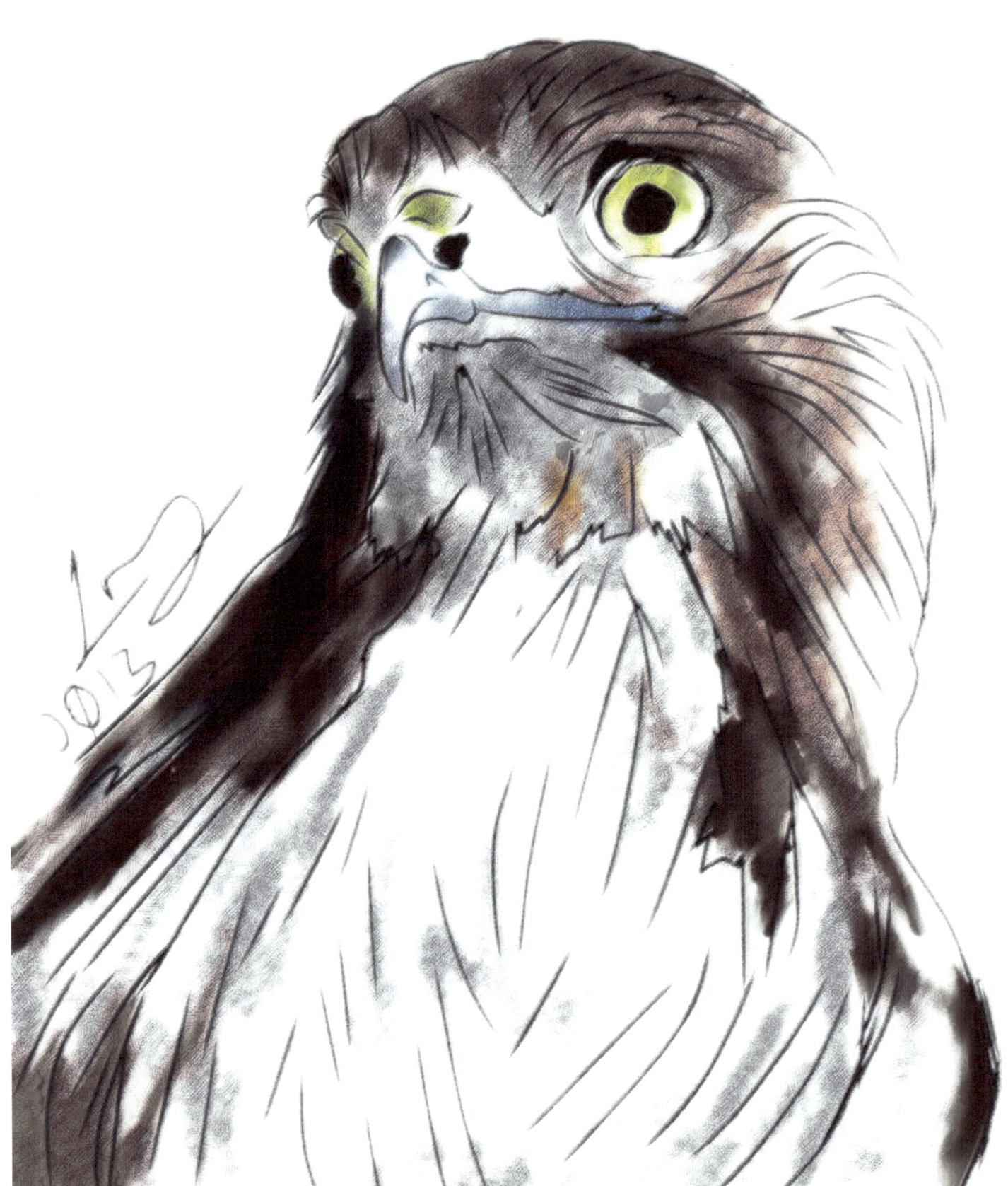

Hans Ulrich Rudel

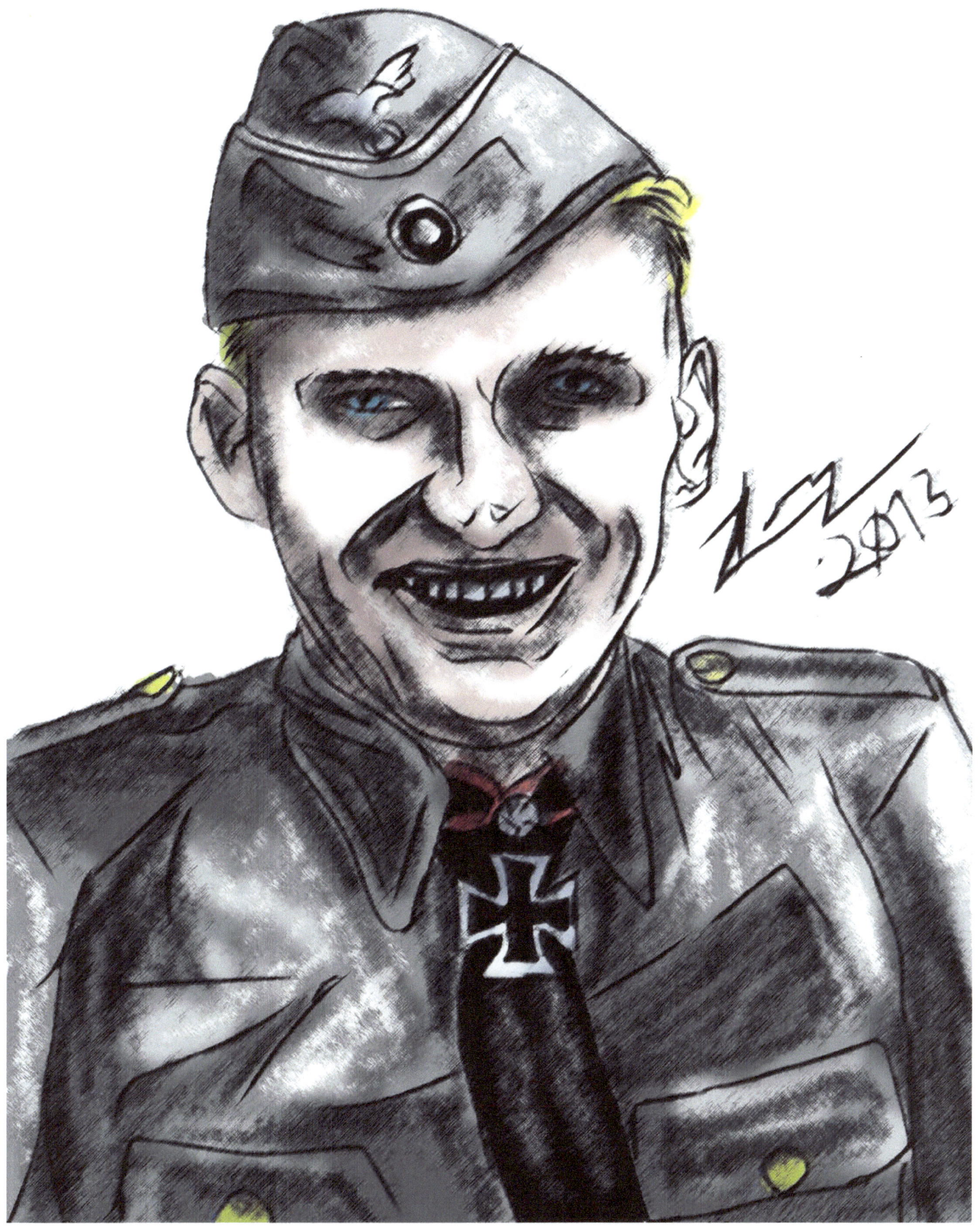

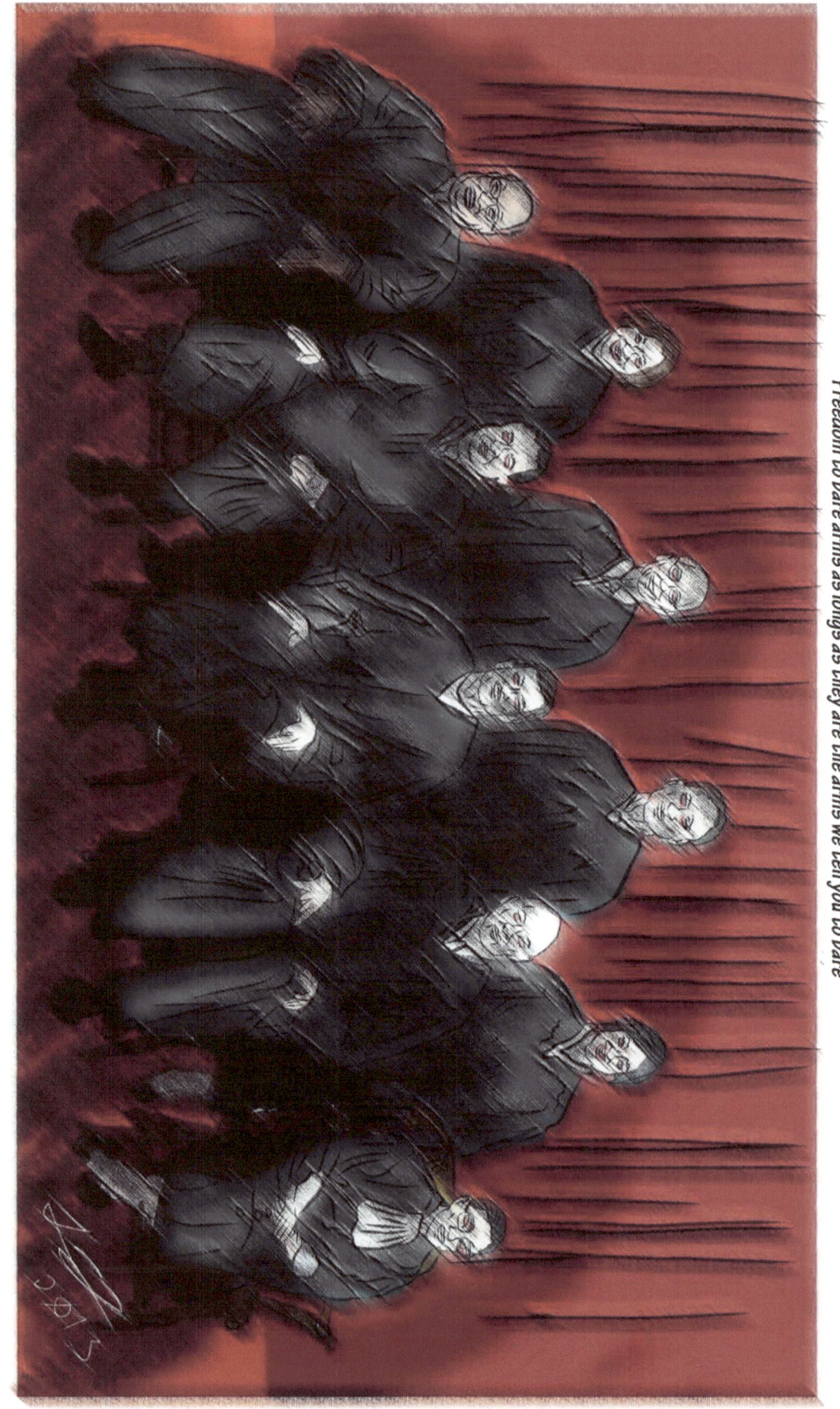

Your rights are what we declare your rights to be...

Freedom of speech as long as you say what we tell you to say
Freedom of press as long as you write what we tell you to write
Freedom to bare arms as longs as they are the arms we tell you to bare

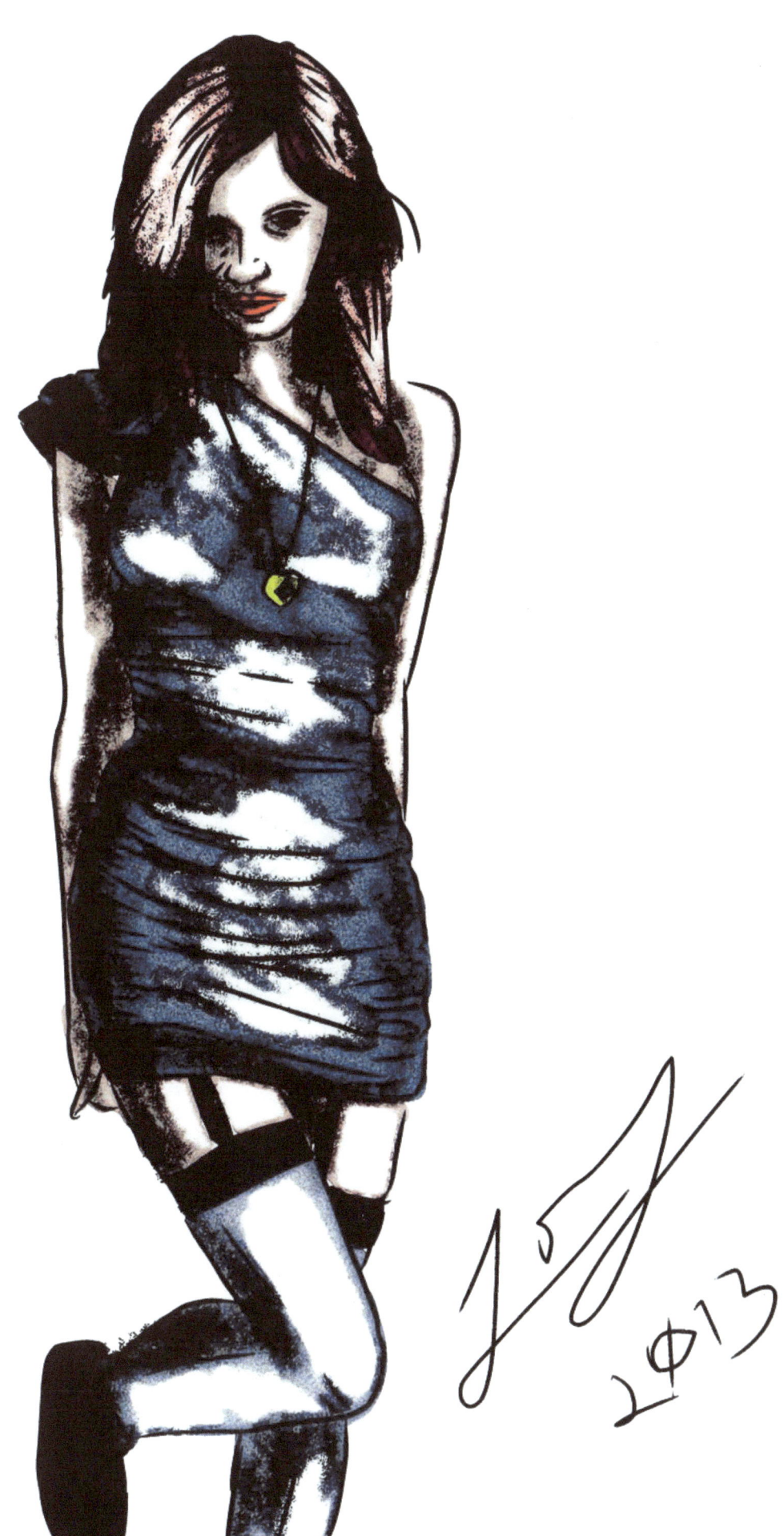

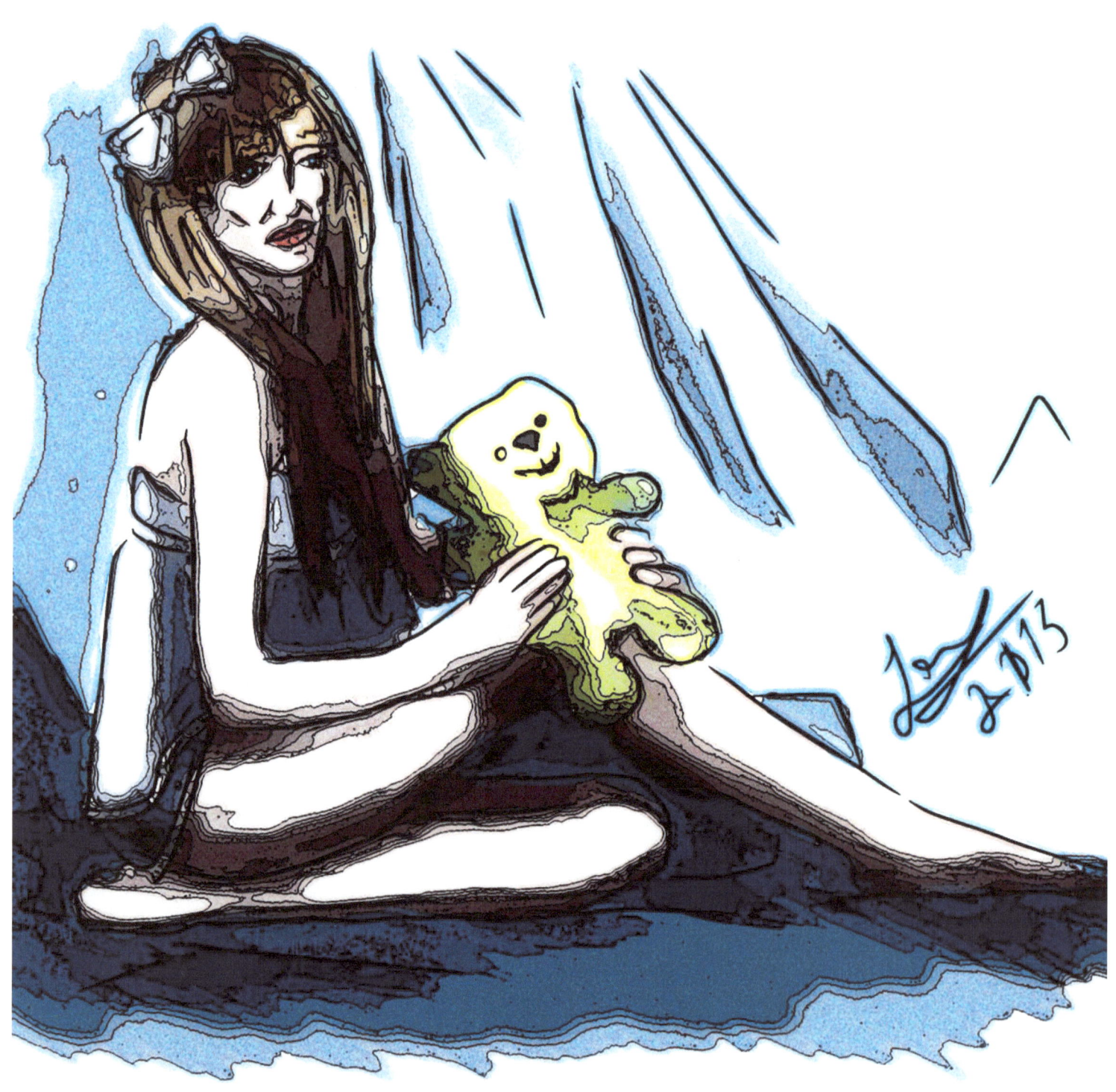

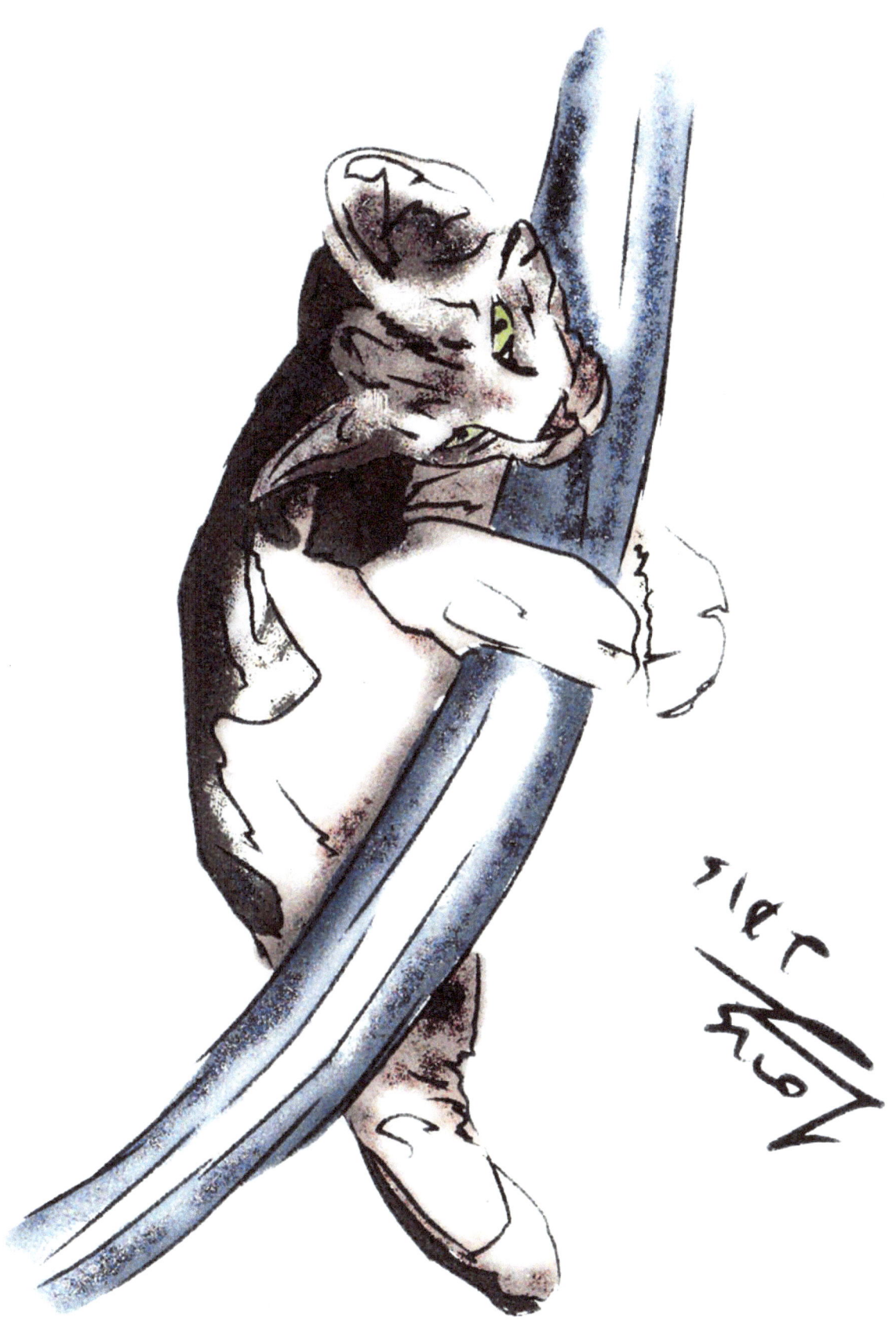

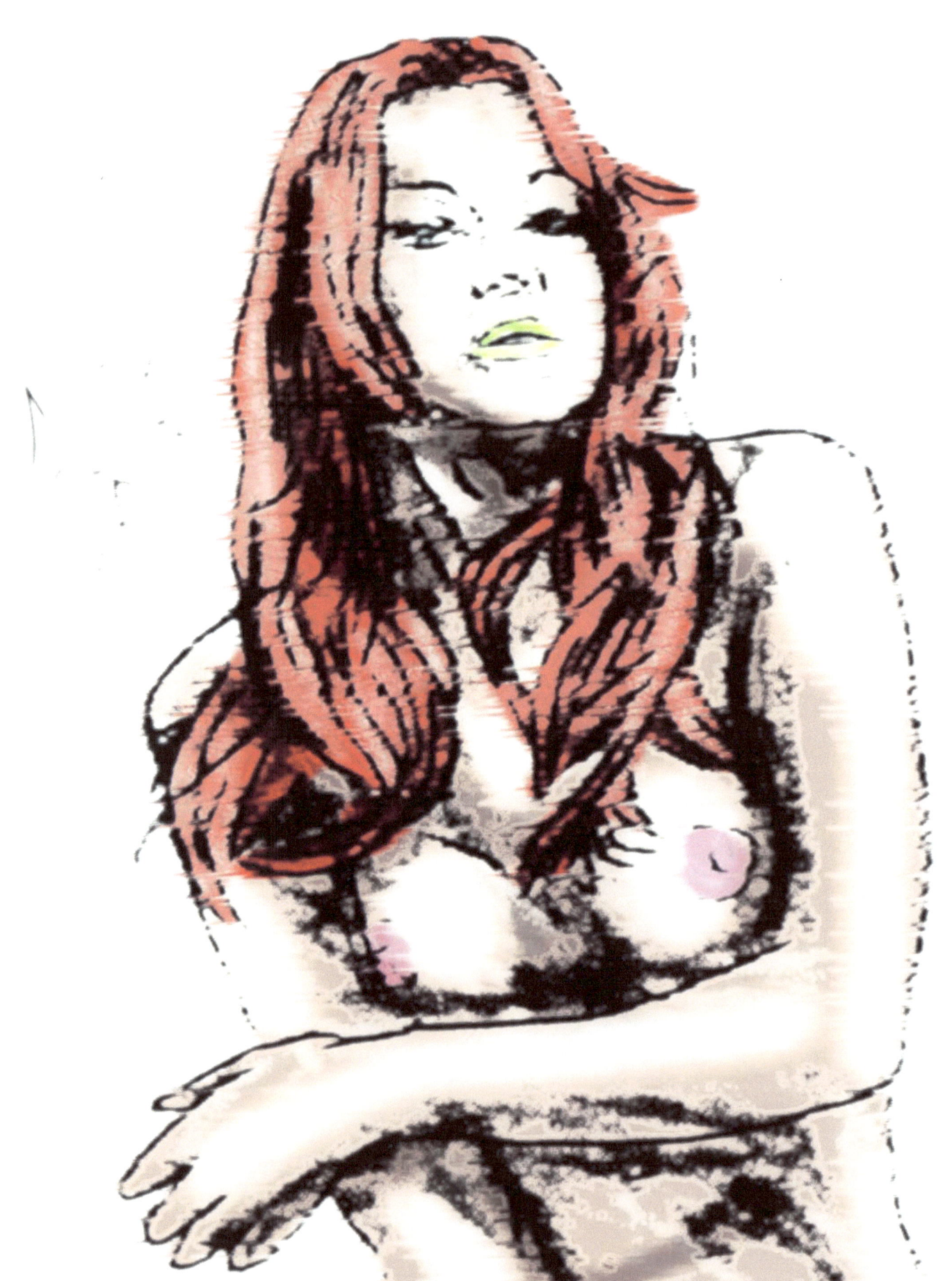

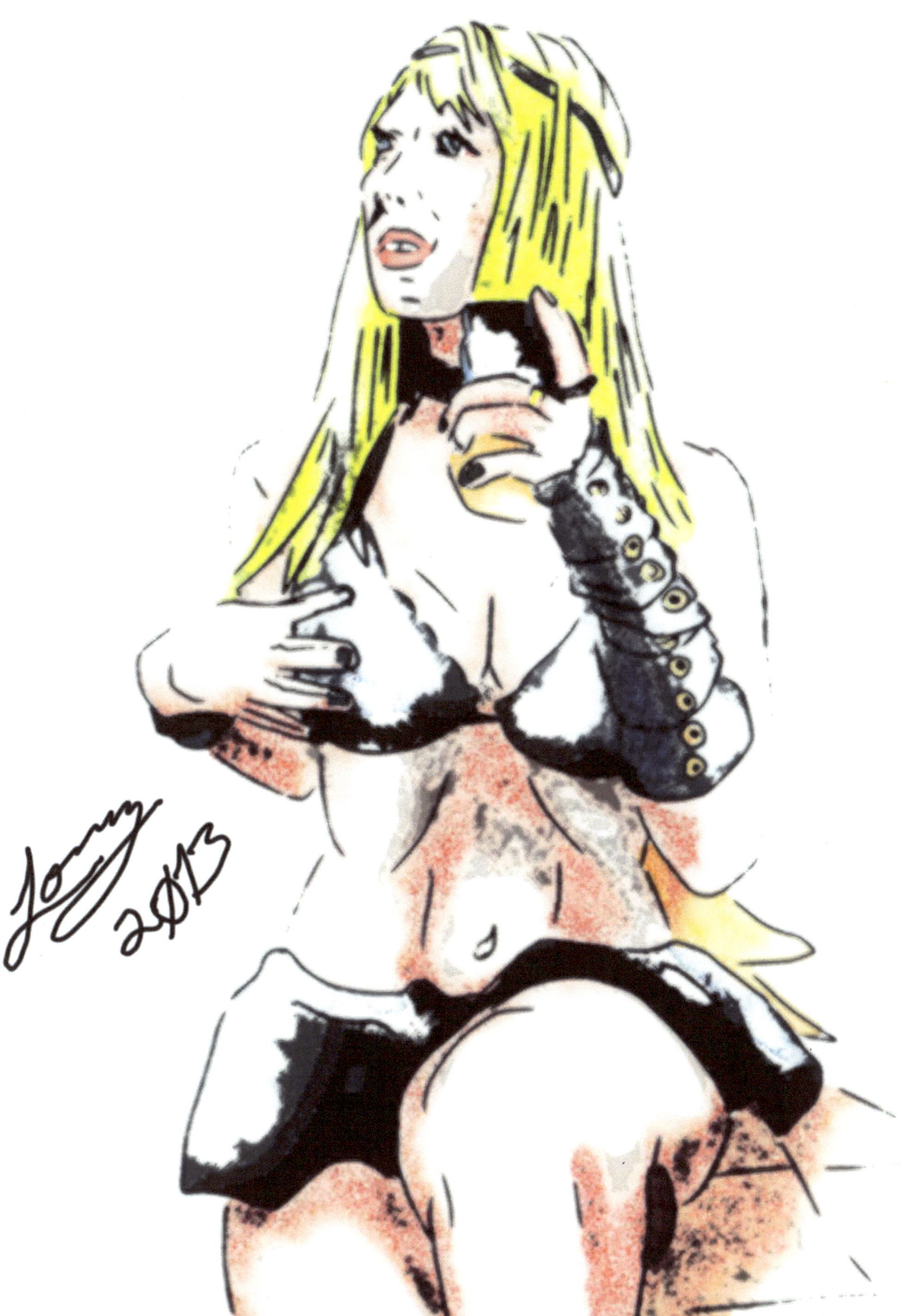

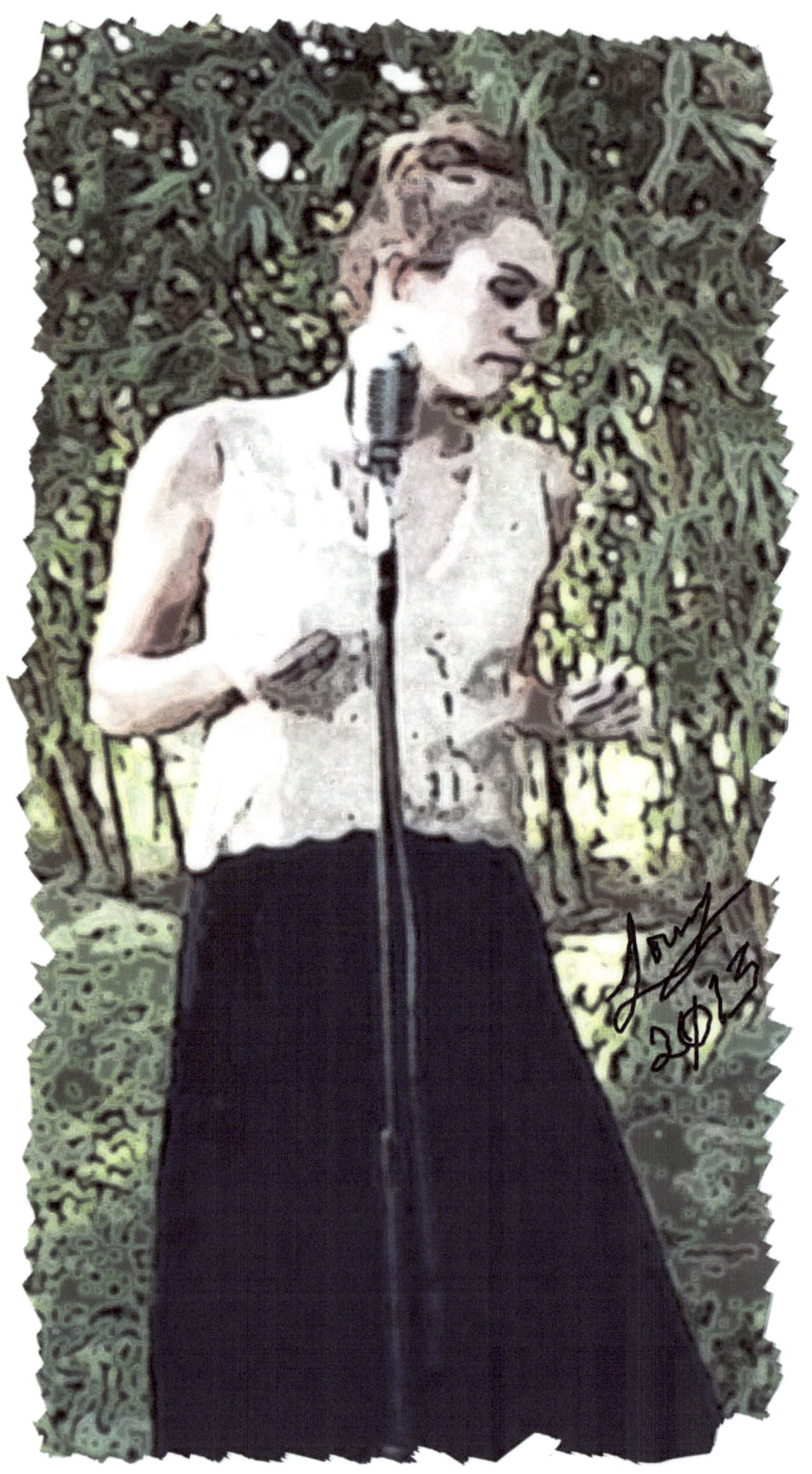

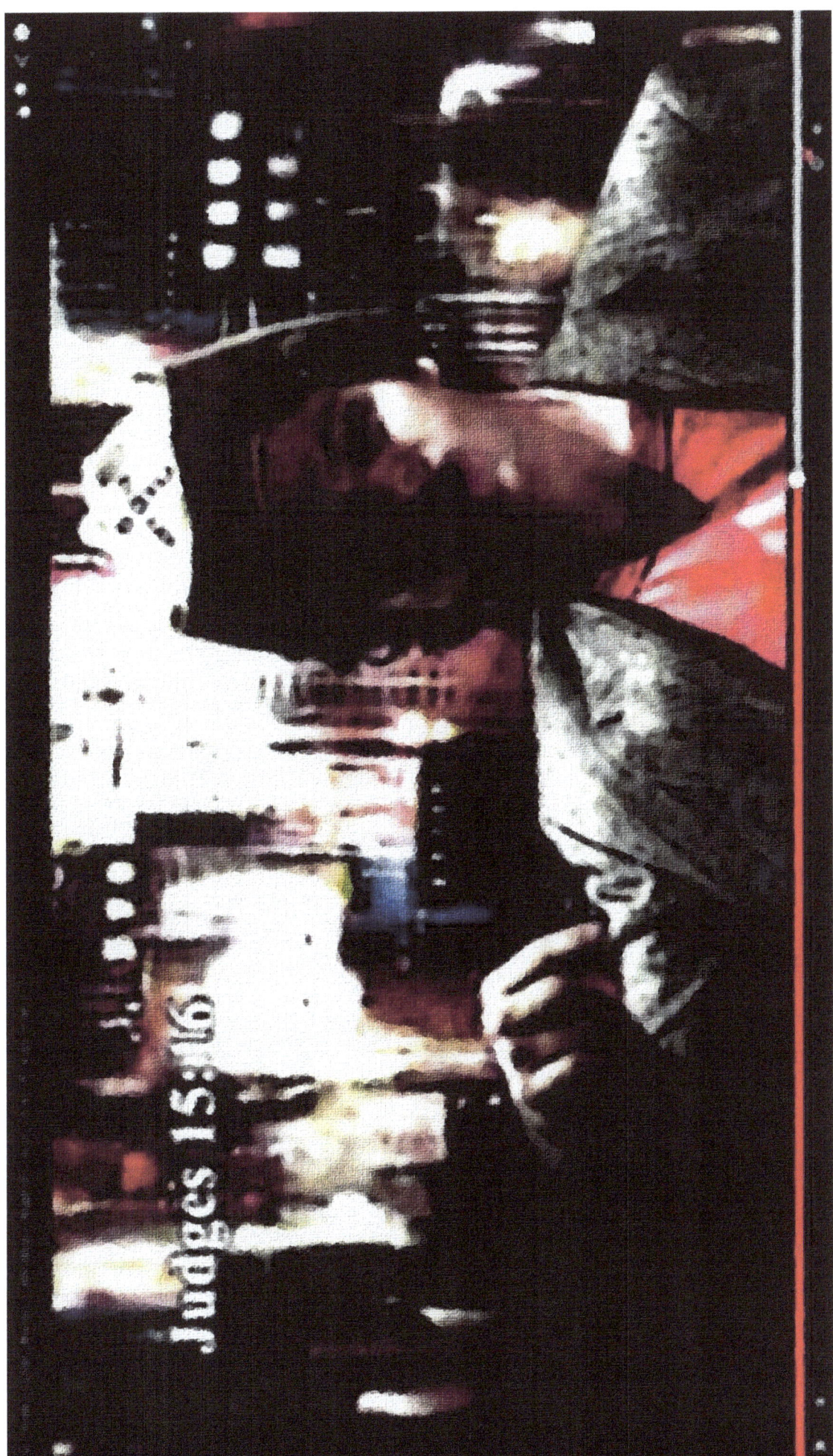

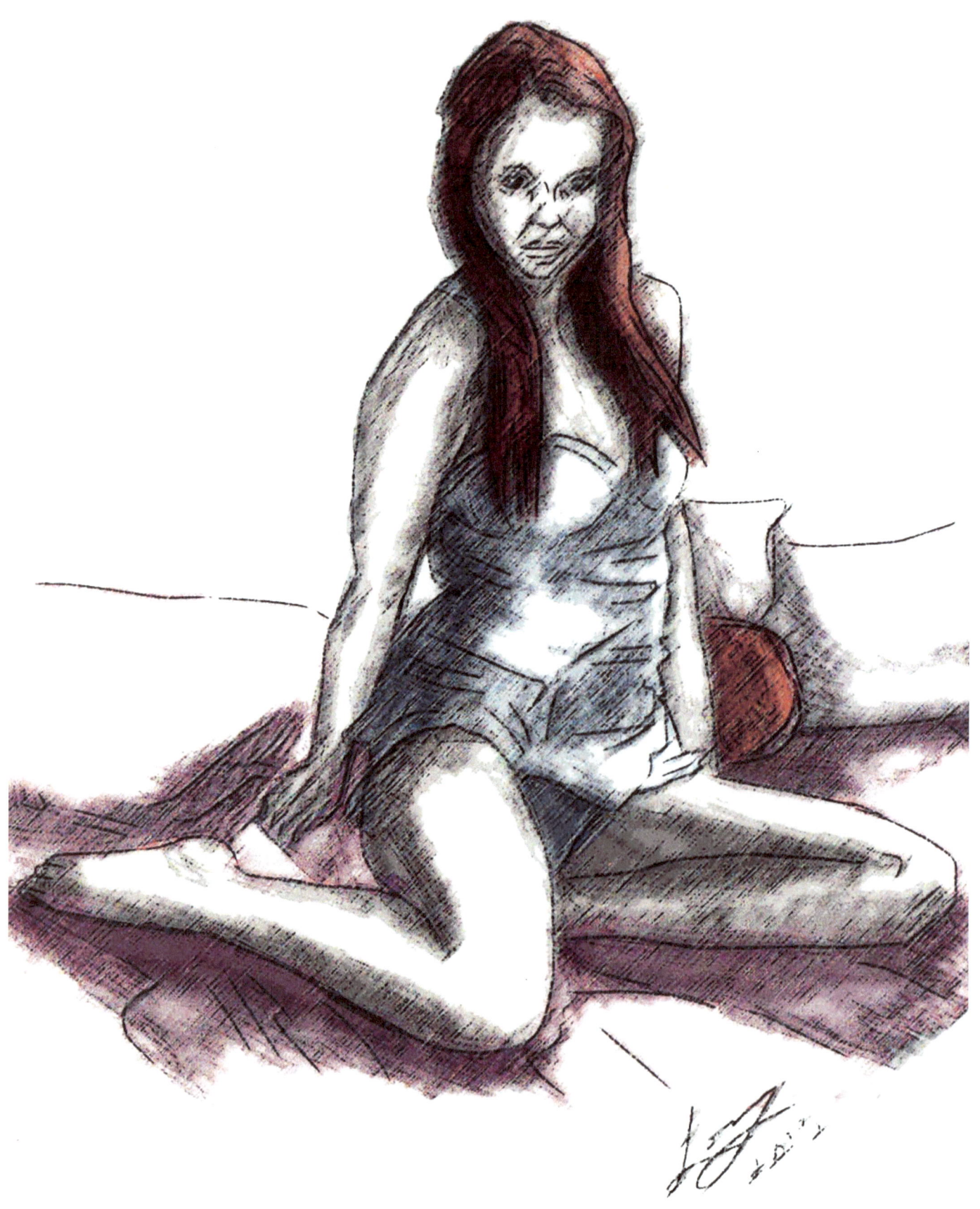

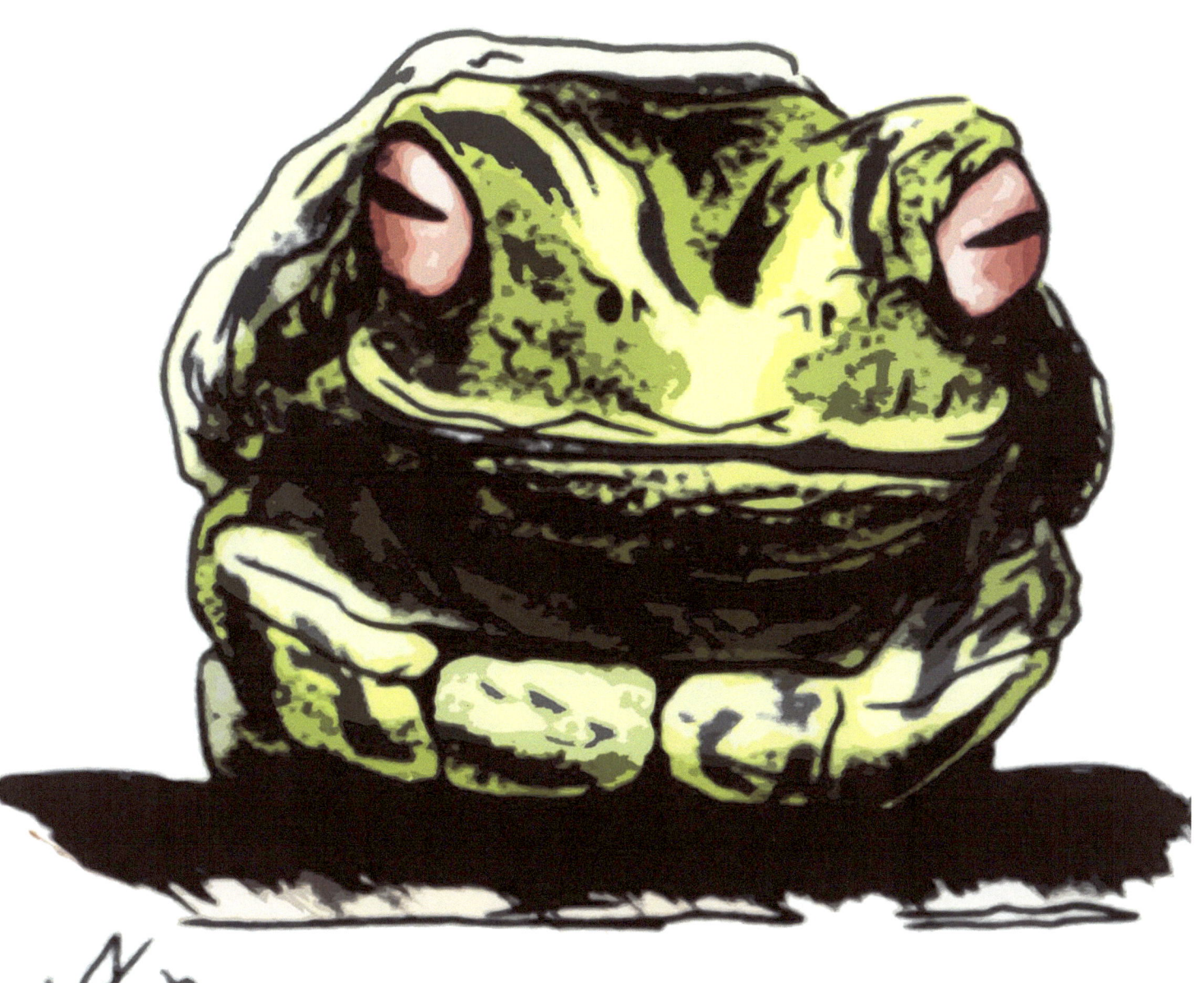

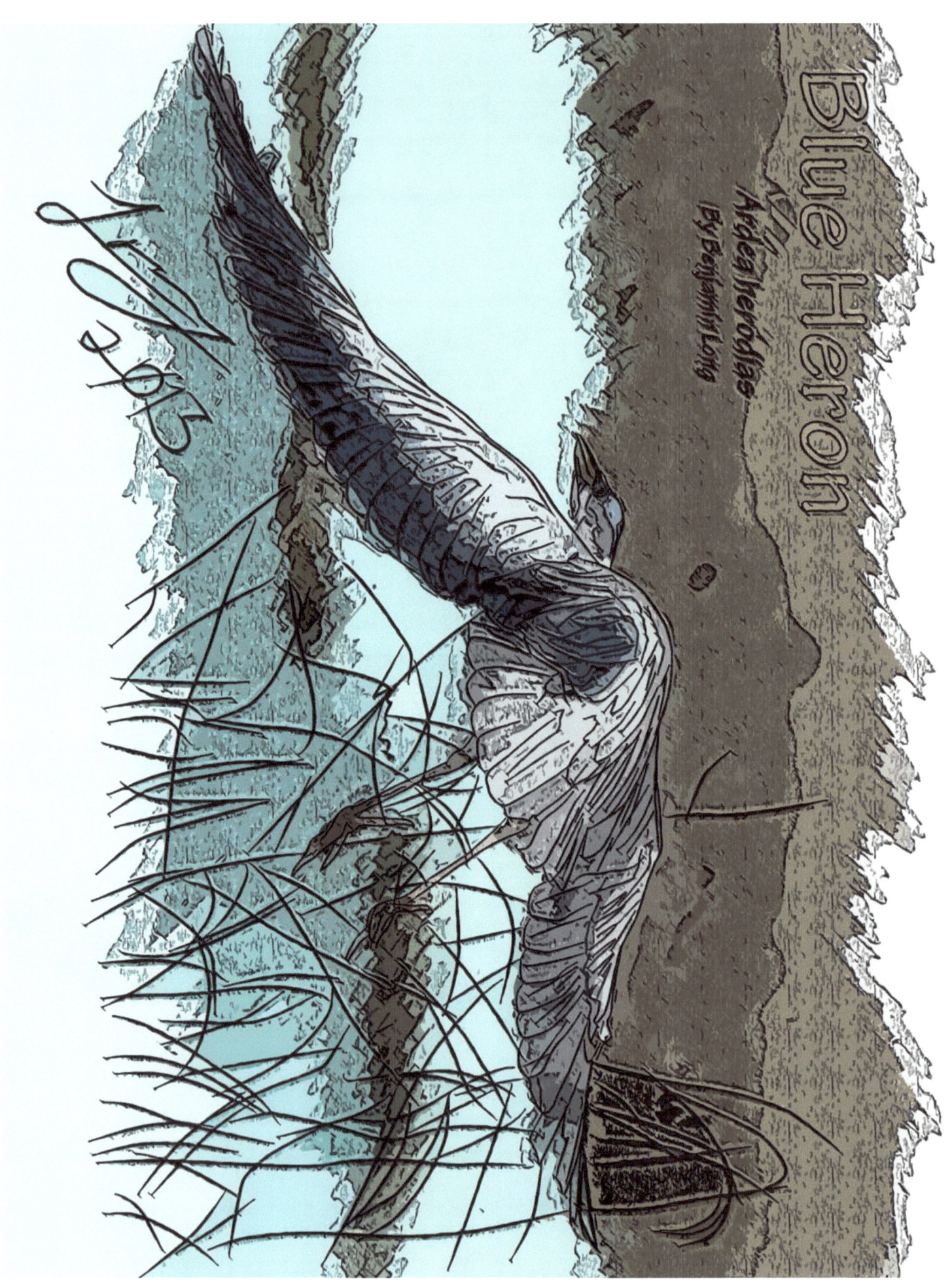

Knee Strike

By Benjamin Long 2013
Referenced from a stock photo by mjranum on DA

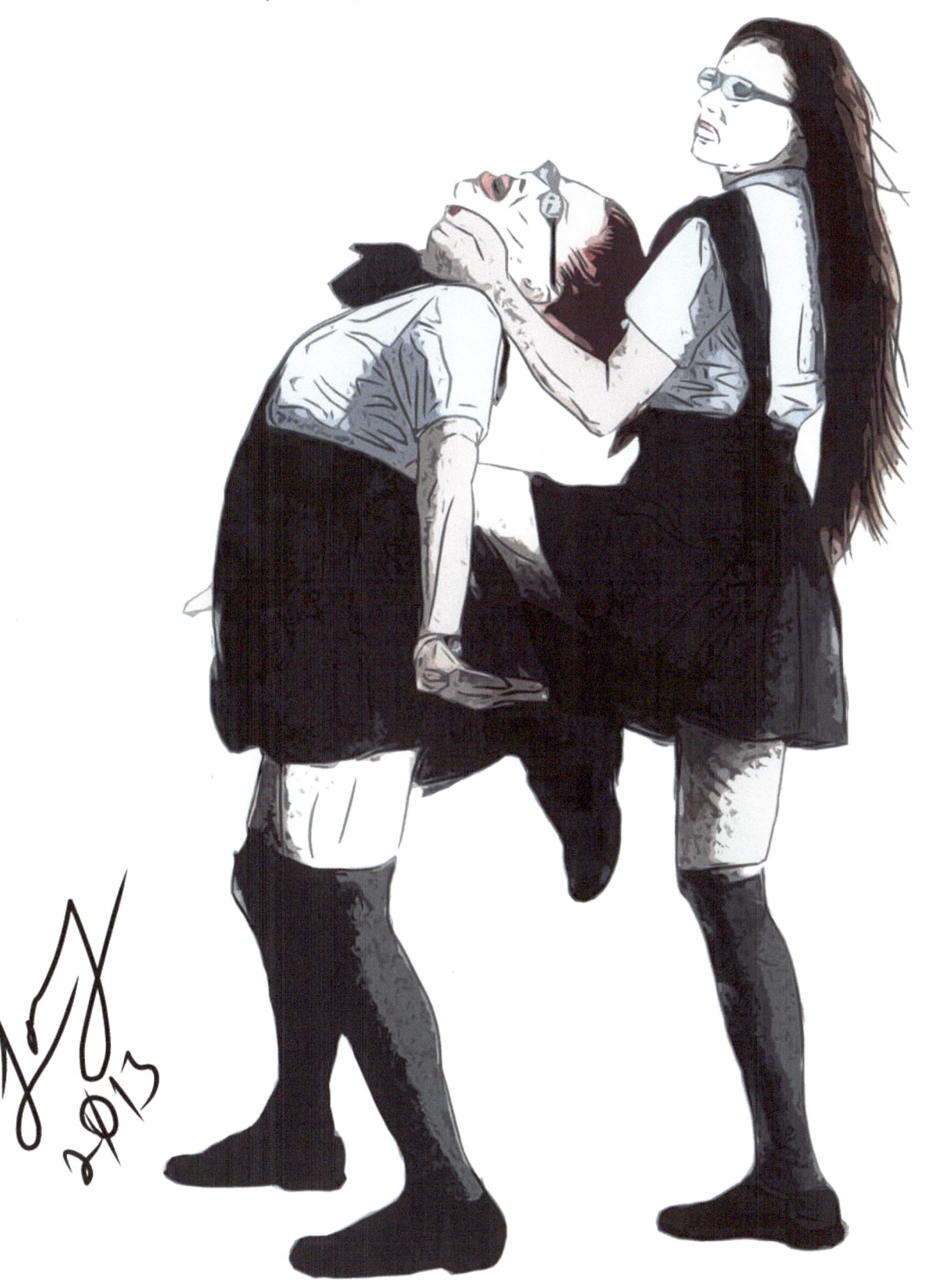

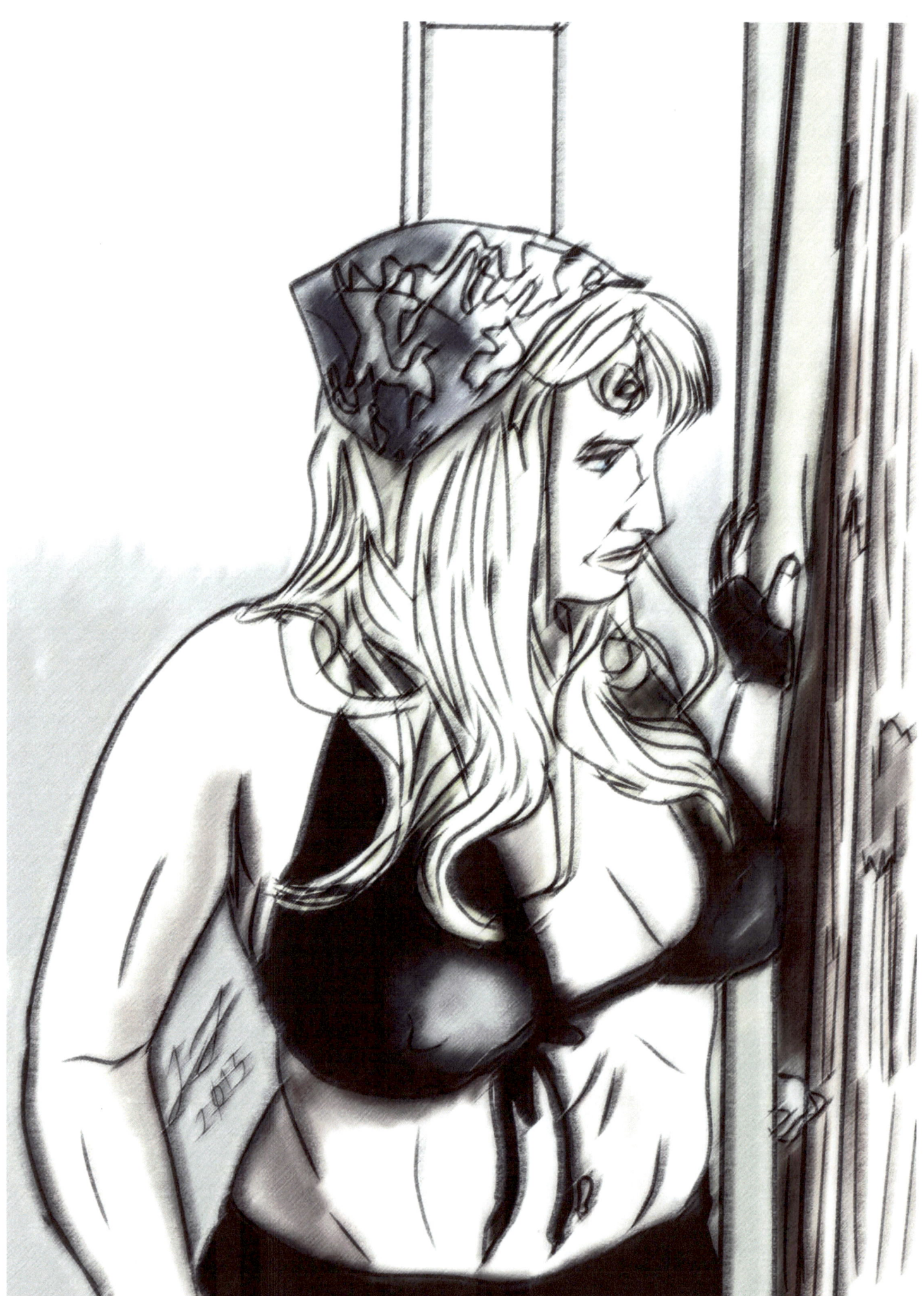

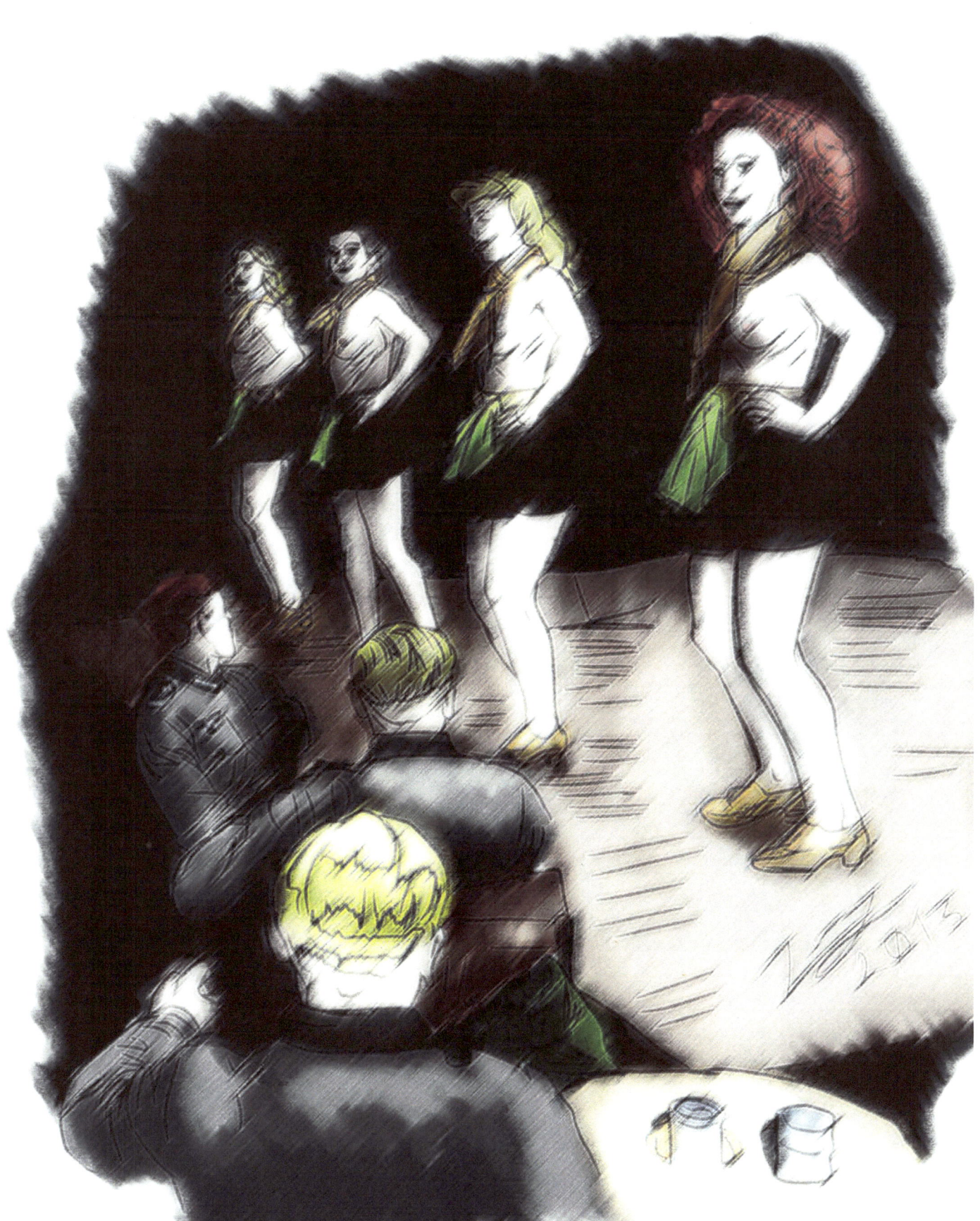

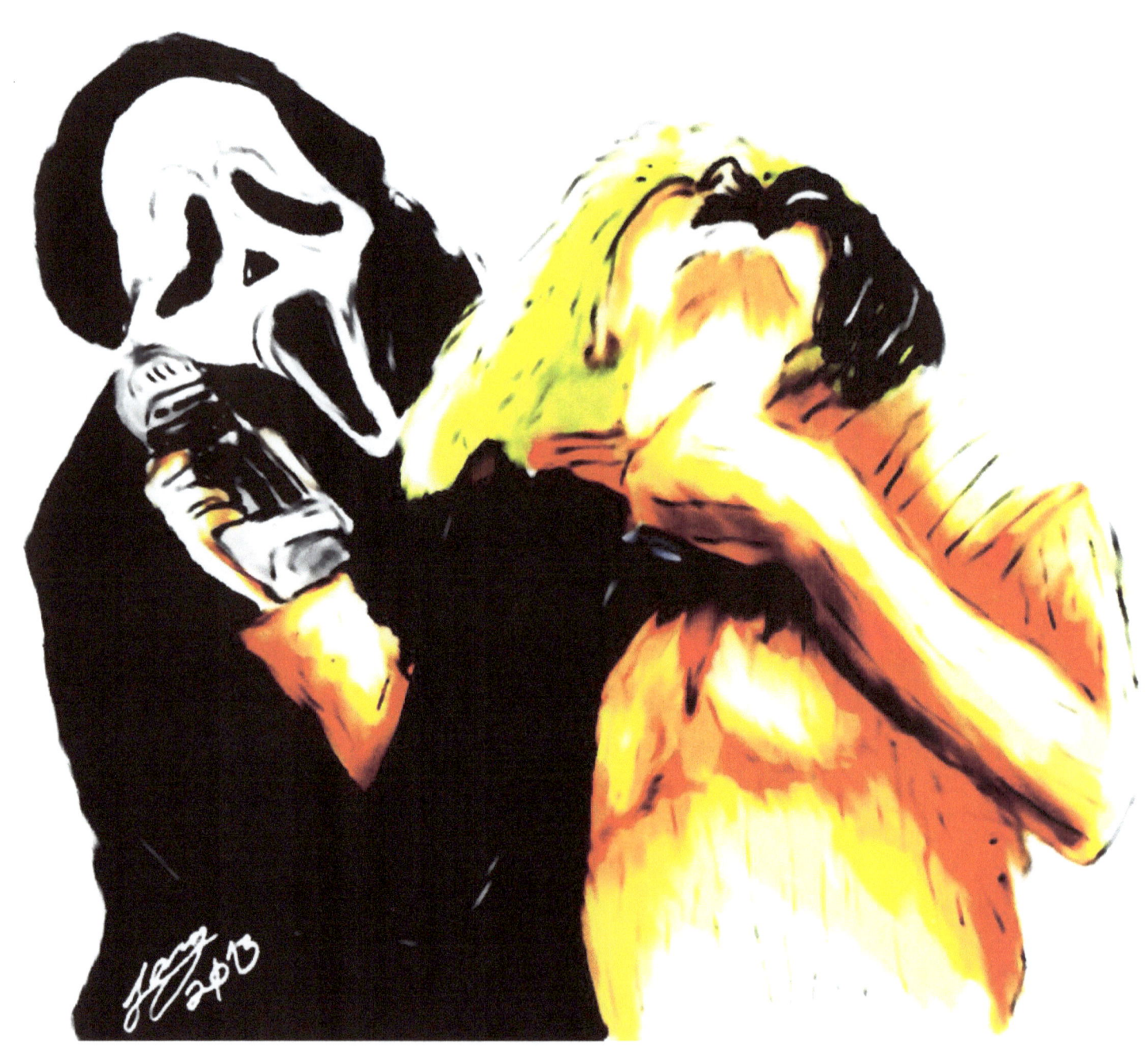

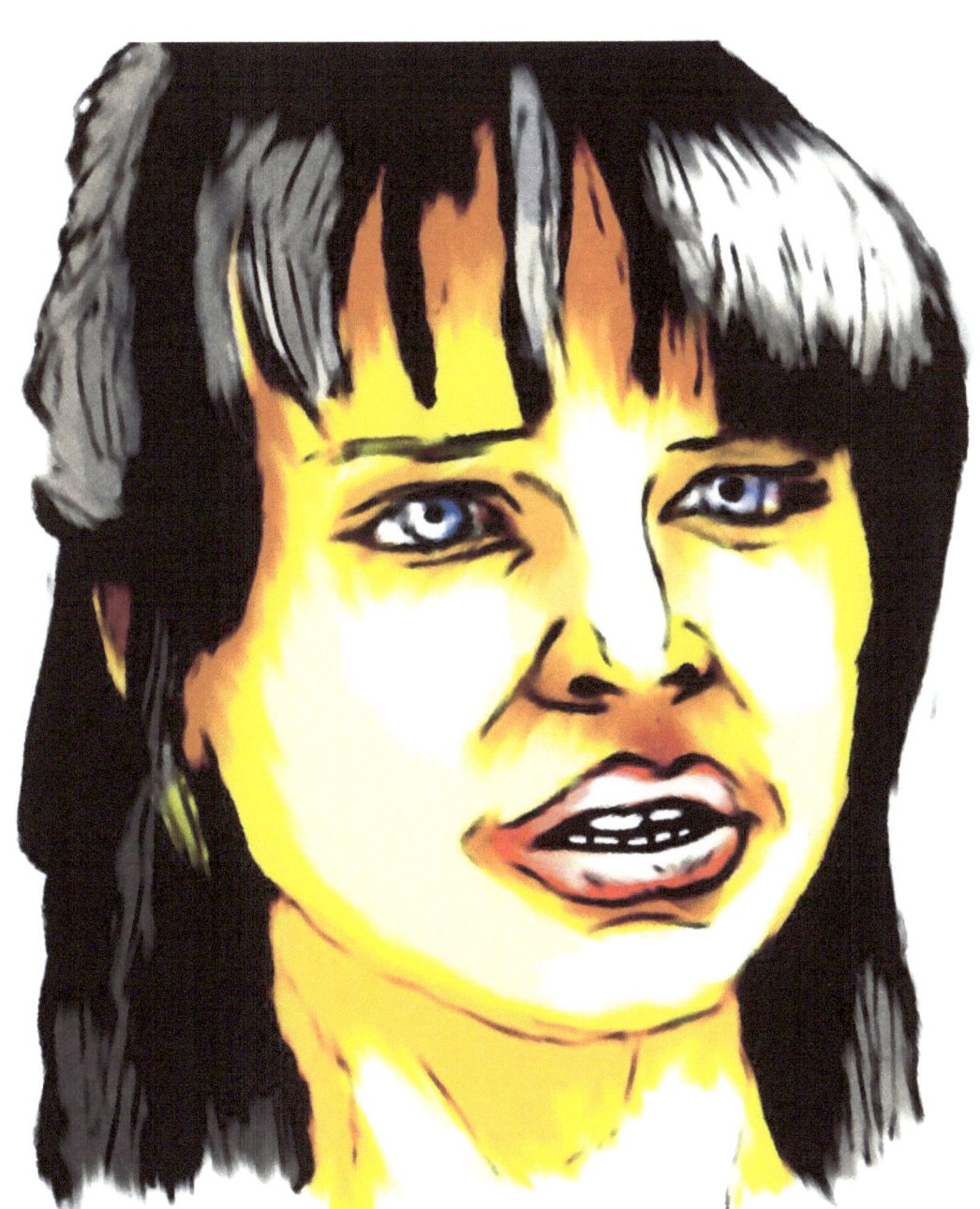

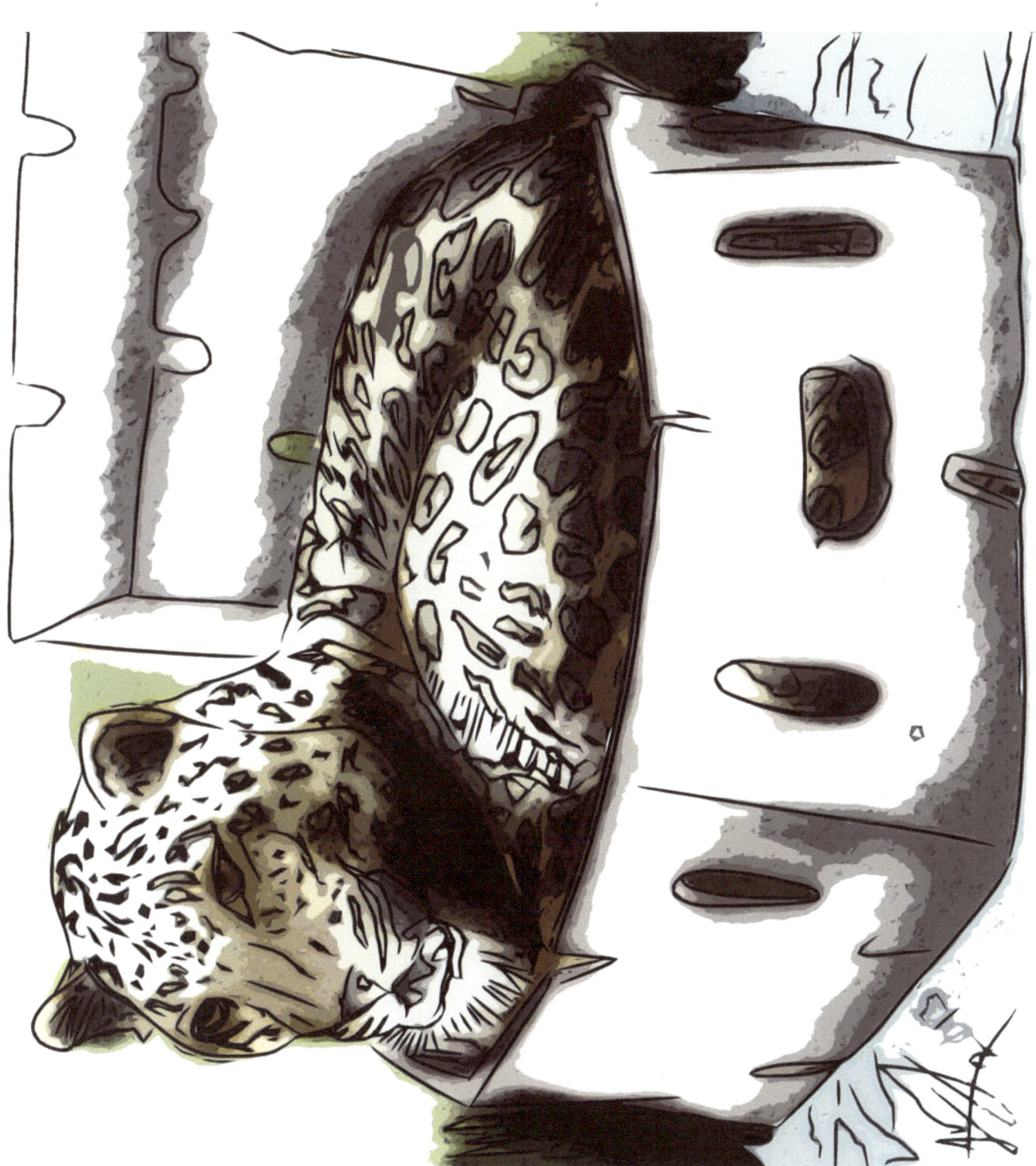

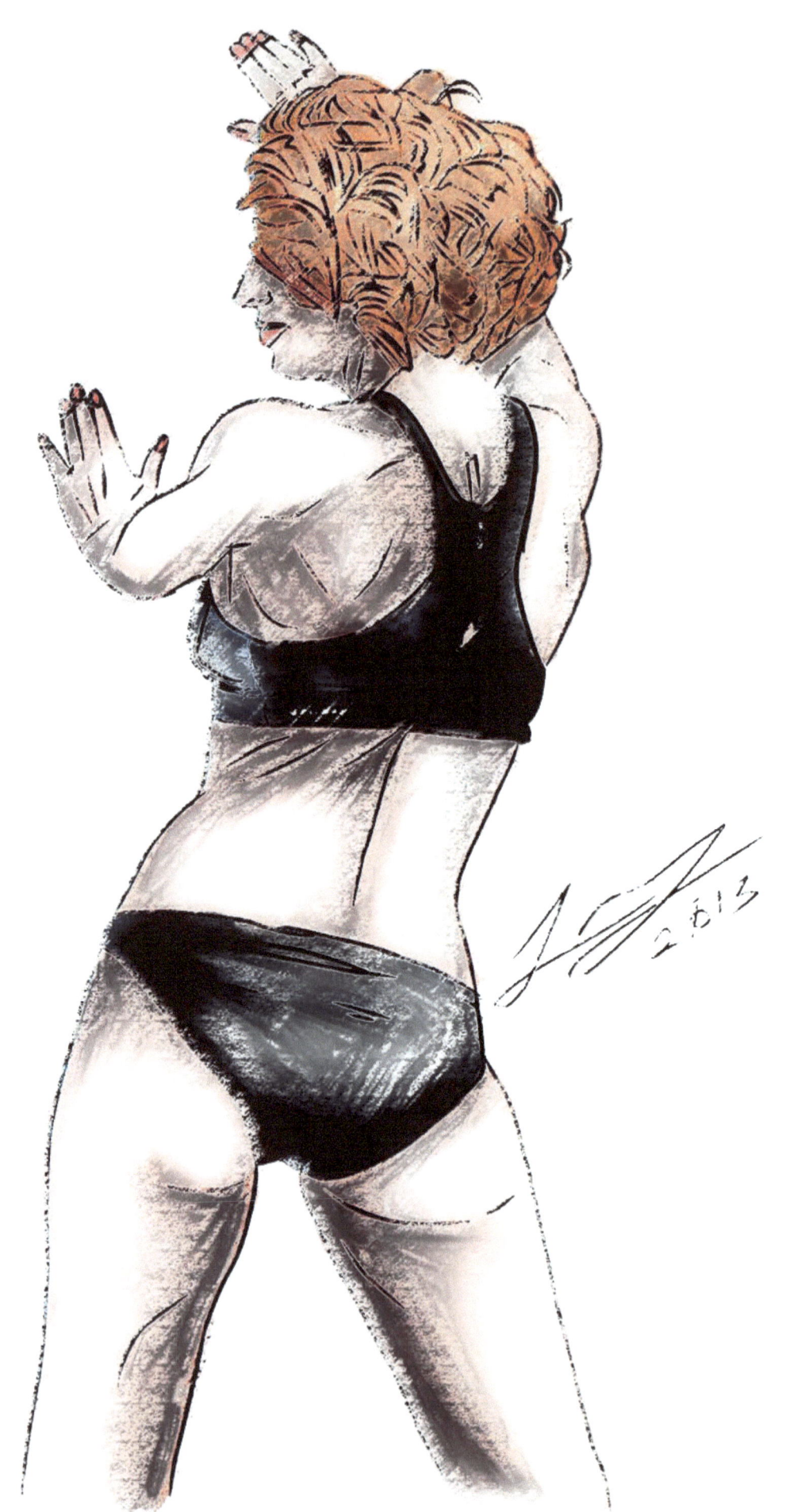

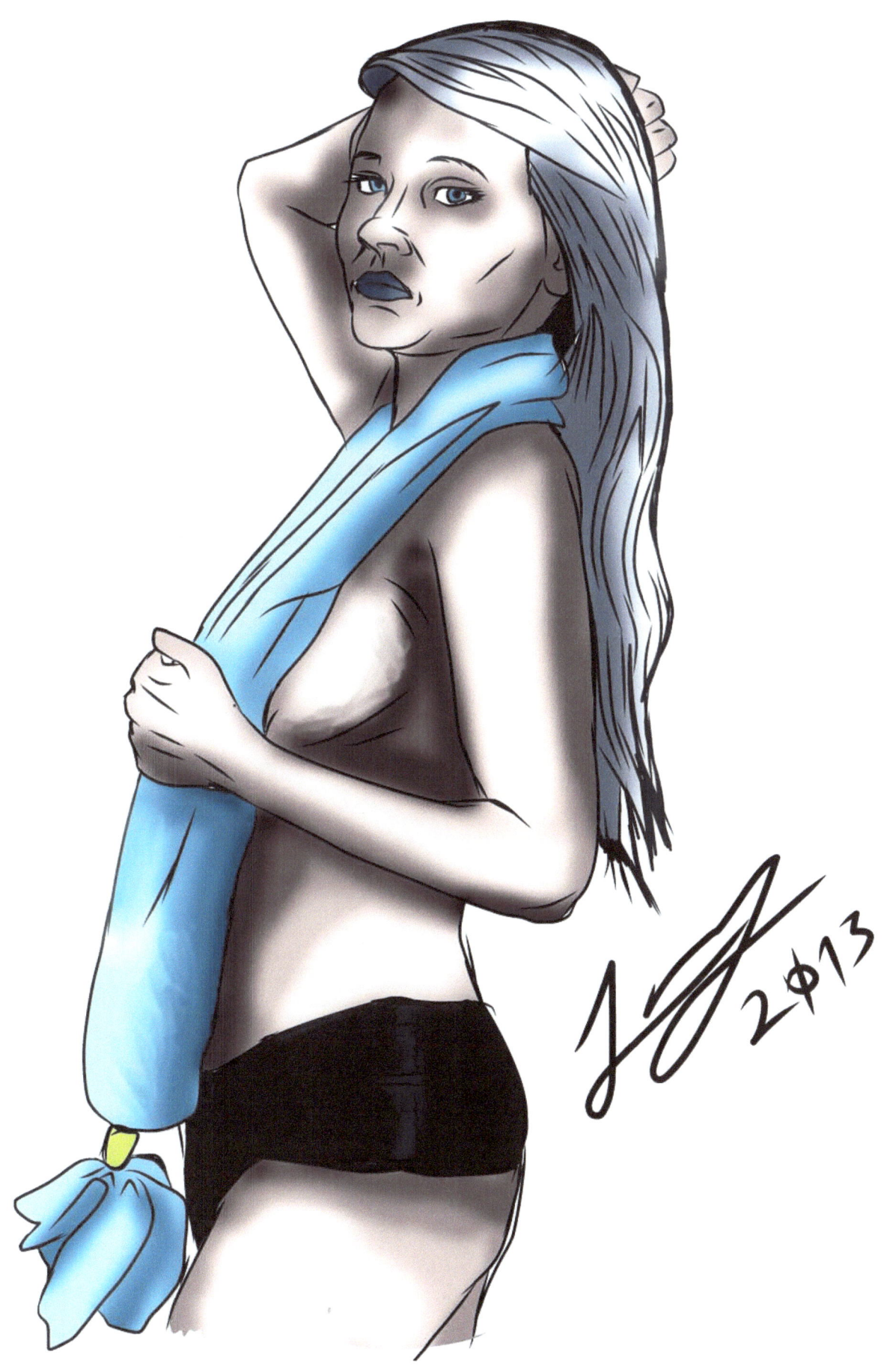

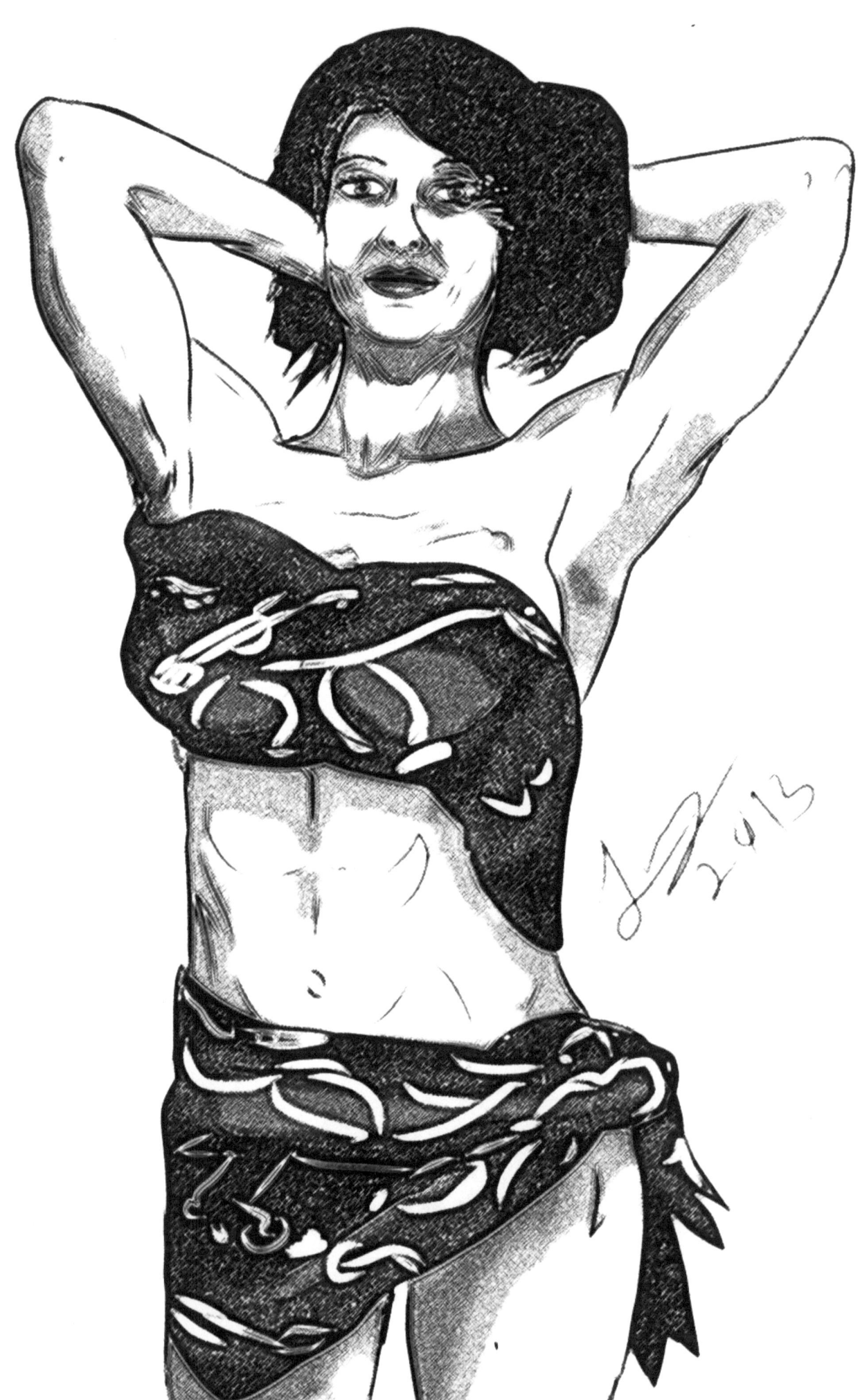

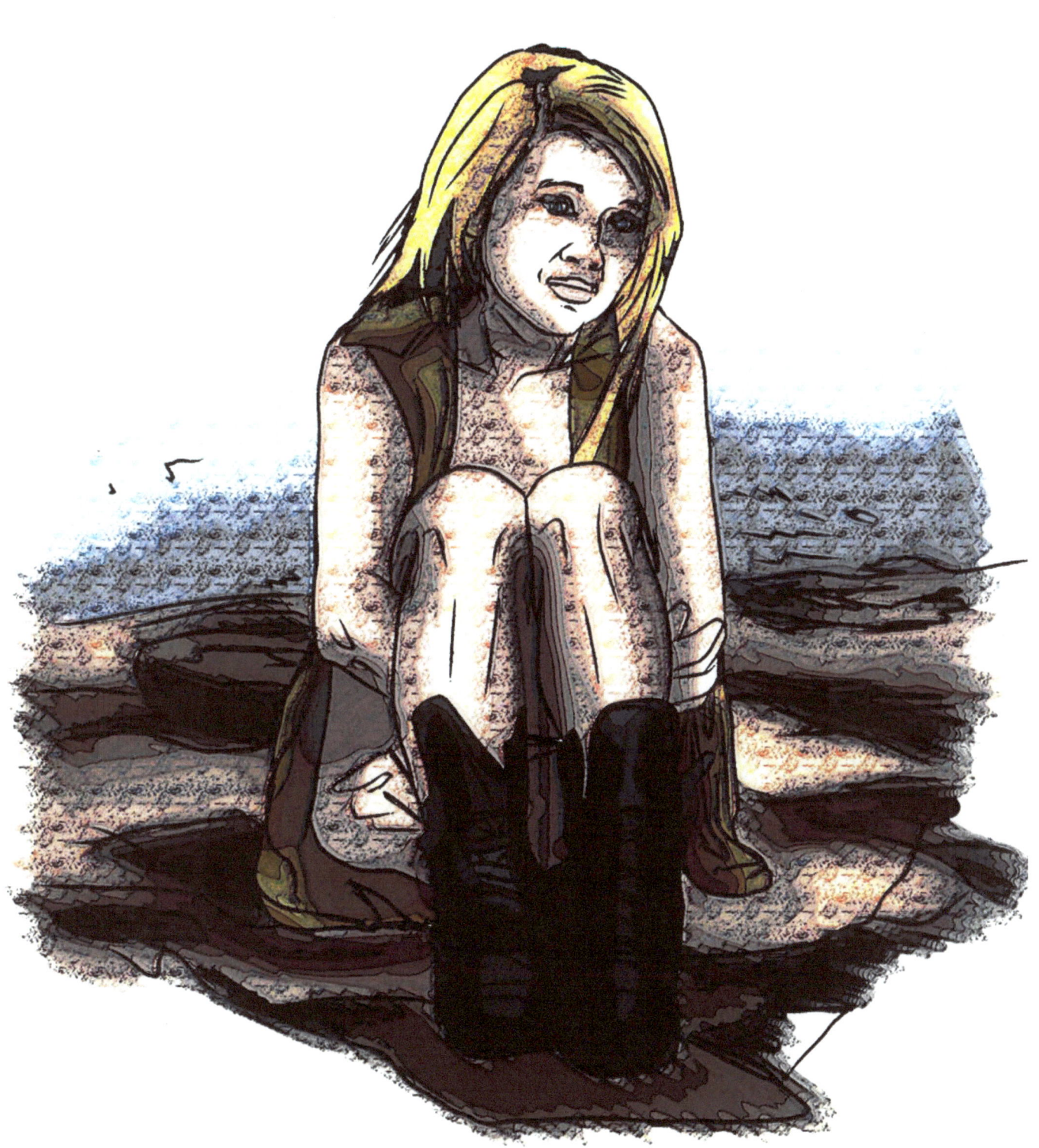

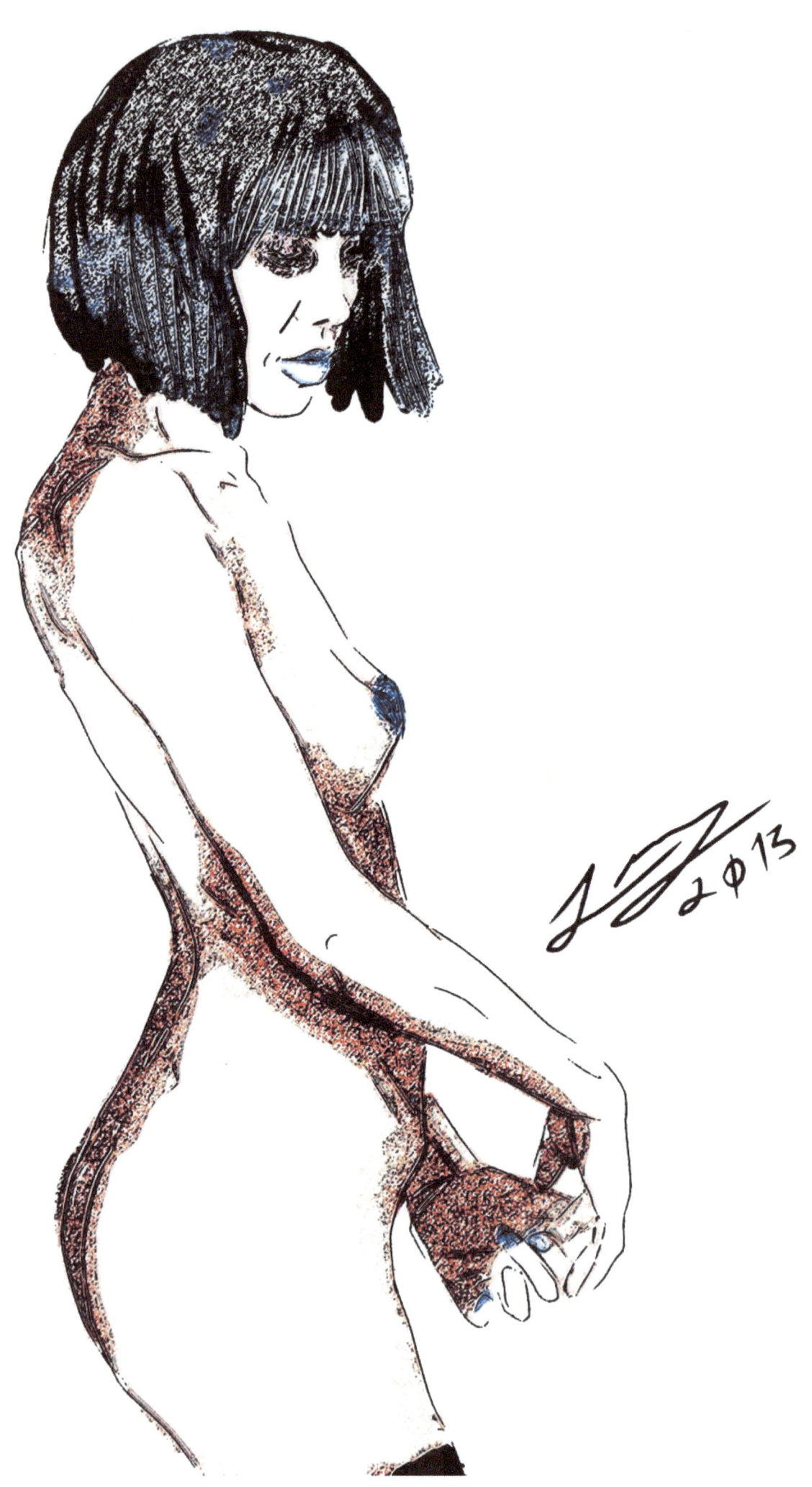

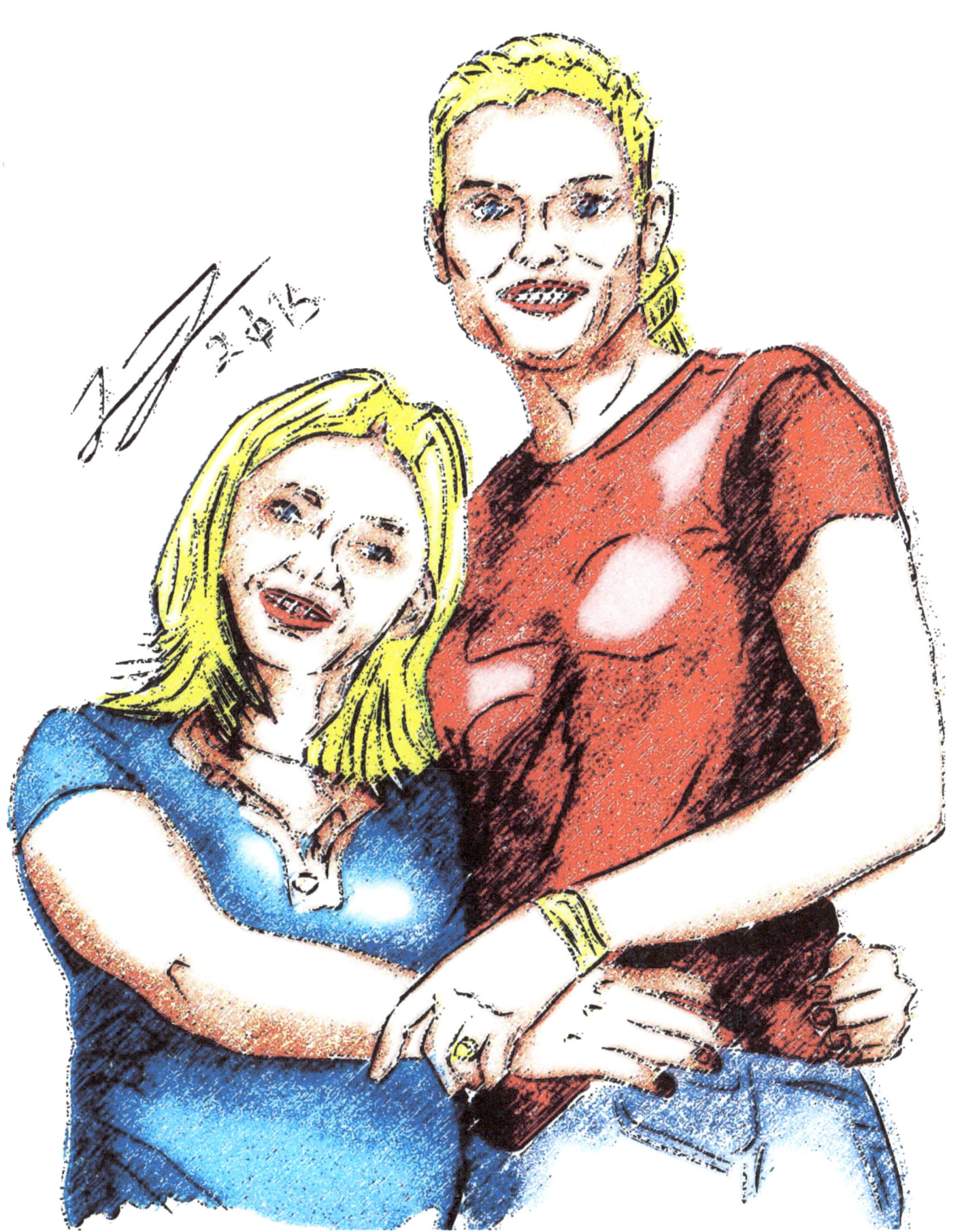

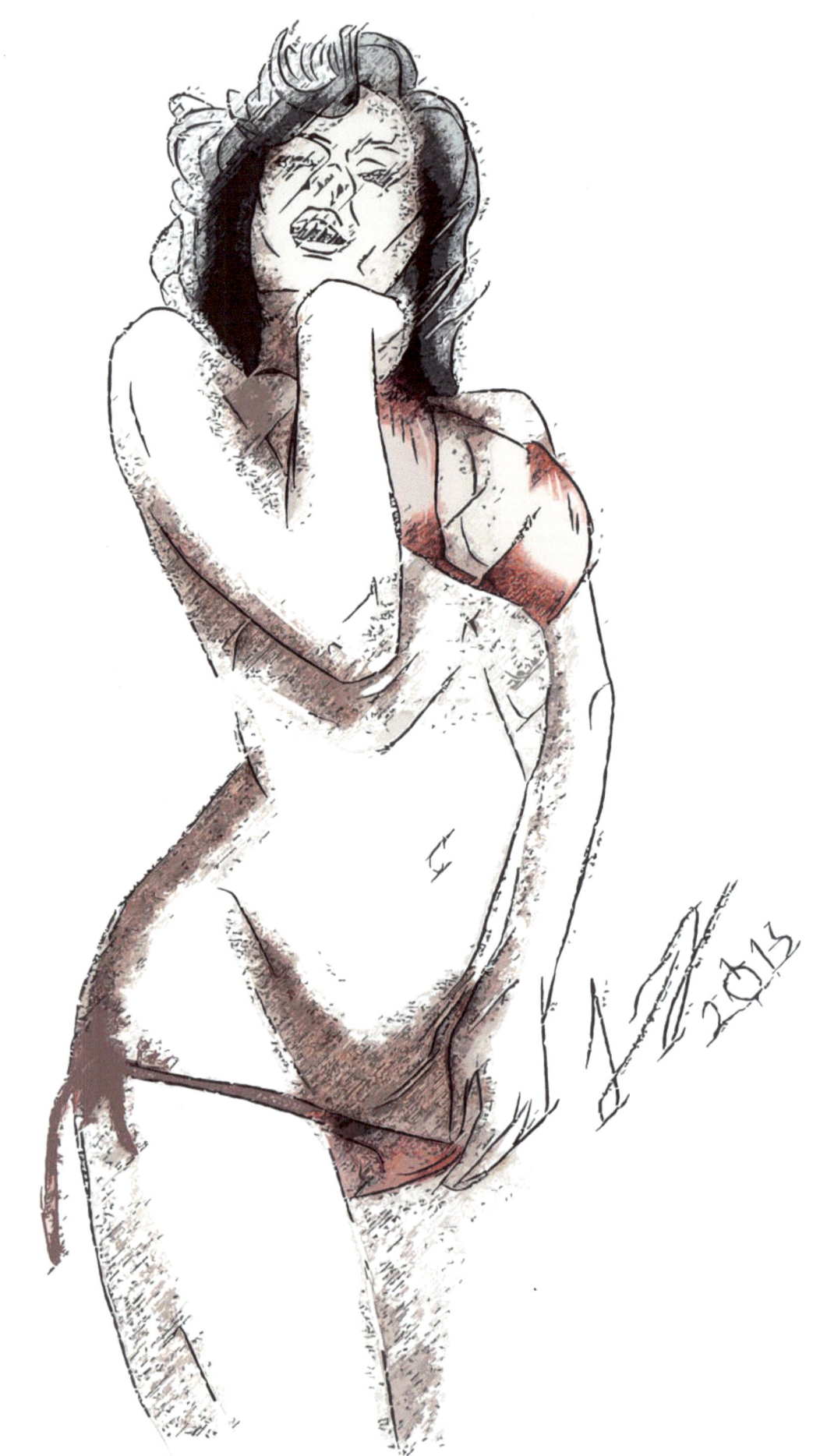

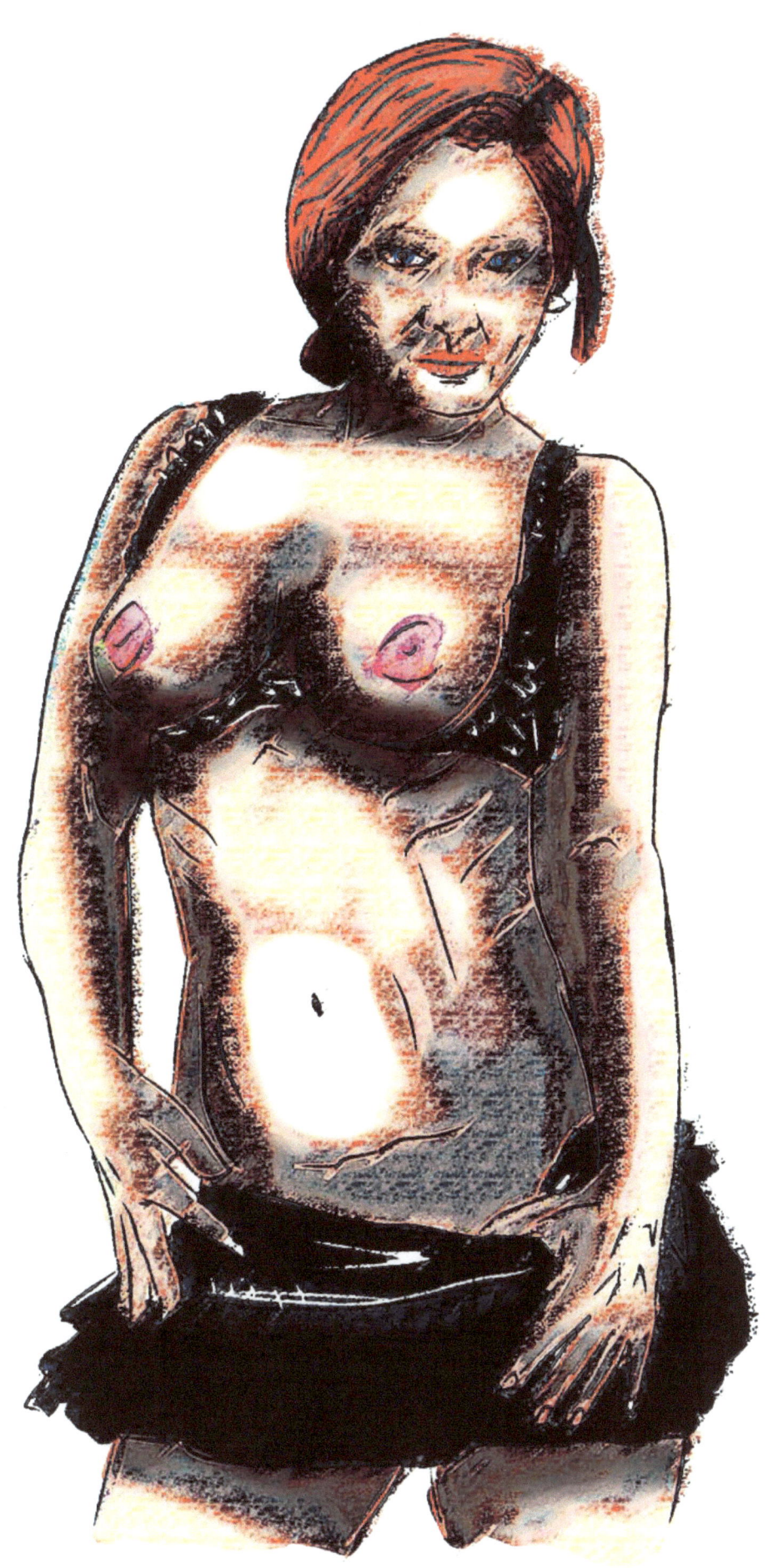

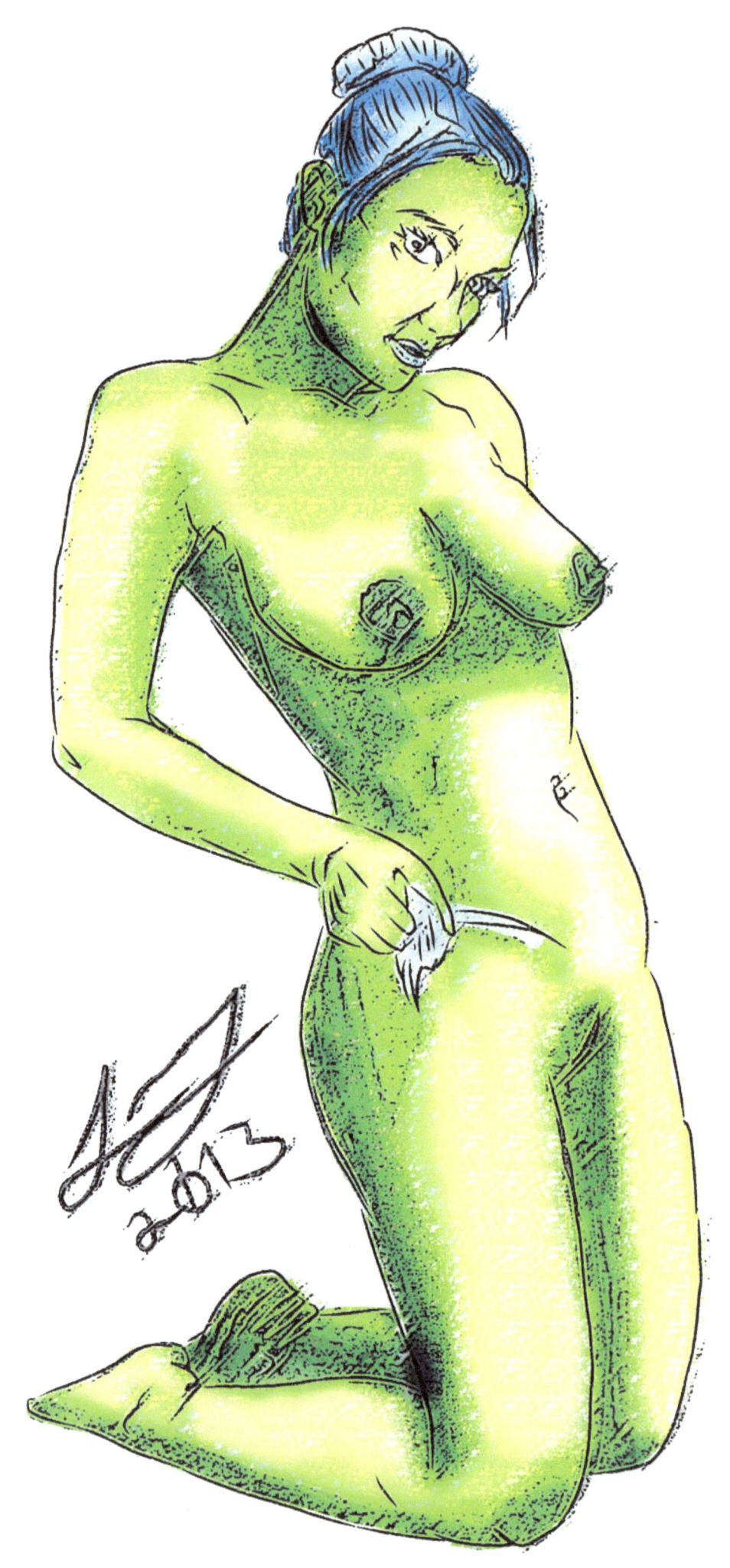

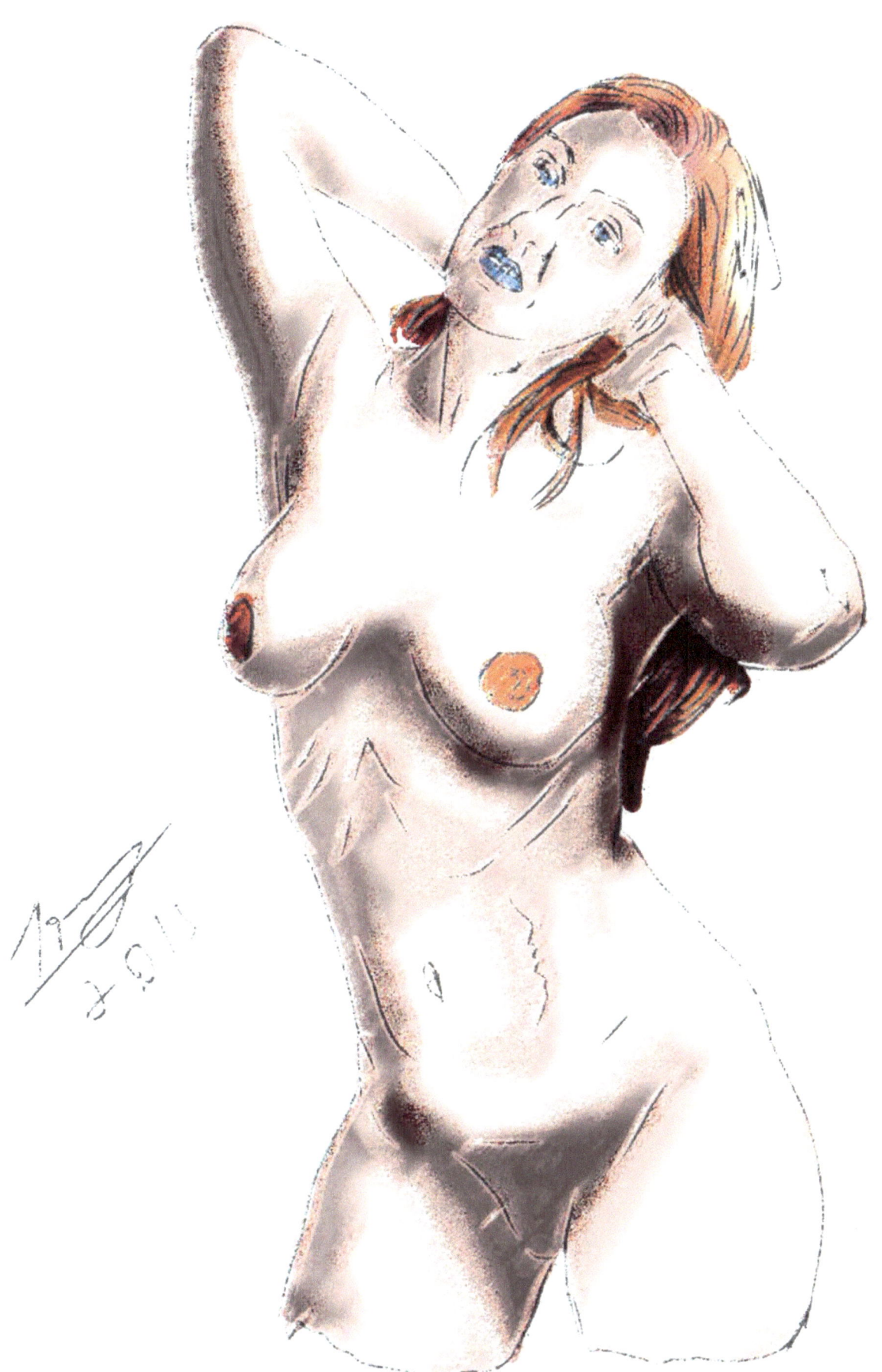

Heathen Art LLC

Benjamin Long, **Illustrator**

The pieces of artwork contained within are the property of Heathen art and Benjamin R Long. No image may be duplicated in part or whole without written permission of Benjamin Long.

Copyrighted images are protected under Title 17 of the USC and traditional copyright applies and duplications must be made in accordance with US law regarding the "Fair use" clause.

Benjamin Long may be contacted on the following Forums:

E-Mail: wiking88142001@yahoo.com

Skype: whitewolfheathen

http://whitewolfheathen.deviantart.com/

Copyright © 2013 (Benjamin Long): All rights reserved.

Commission rates :

Rough Sketch $8 USD

Digital Drawing/Painting $25 USD

Traditional Drawing/Painting on Canvas Panel 8x10 $35 USD

Traditional Drawing/Painting on Canvas Panel 16x20 $80 USD